Art in Context

Edited by John Fleming and Hugh Honour

Each volume in this series discusses a famous painting or sculpture as both image and idea in its context – whether stylistic, technical, literary, psychological, religious, social or political. In what circumstances was it conceived and created? What did the artist hope to achieve? What means did he employ, subconscious or conscious? Did he succeed? Or how far did he succeed? His preparatory drawings and sketches often allow us some insight into the creative process and other artists' renderings of the same or similar themes help us to understand his problems and ambitions. Technique and his handling of the medium are fascinating to watch close up. And the work's impact on contemporaries and its influence on other artists can illuminate its meaning for us today.

By focusing on these outstanding paintings and sculptures our understanding of the artist and the world in which he lived is sharpened. But since all great works of art are unique and every one presents individual problems of understanding and appreciation, the authors of these volumes emphasize whichever aspects seem most relevant. And many great masterpieces, too often and too easily accepted and dismissed because they have become familiar, are shown to contain further and deeper layers of meaning for us.

John Trumbull was born at Lebanon, Connecticut, on 6 June 1756, youngest of the three sons and two daughters of Jonathan and Faith Robinson Trumbull. The Trumbull family had been in America for about one hundred years, prospering as merchants and farmers. John's father played an active role in the colony's political life, becoming governor in 1769; he was the only colonial governor to support the American side in the Revolution, and the entire family was closely identified with the Patriots' cause. This was an important factor in shaping John Trumbull's professional career as a history painter. Young Trumbull served in the Revolution, rising to the rank of colonel. He resigned in a huff over a misdated commission, and settled in Boston, where he took rooms in the house formerly occupied by John Smibert (1688–1751), one of America's first professional artists. Self-taught until after the war, he went to England to study with Benjamin West in 1780. With West and Copley he became one of the founders of the modern school of contemporary history painting. His most important historical works were largely composed and painted between 1786–93. Trumbull also served the United States as a diplomat; he was John Jay's secretary when the former first Chief Justice of the United States Supreme Court was sent to England to negotiate what has become known as 'The Jay Treaty'. He continued to serve, after the Treaty was signed, as a commissioner to implement its terms. When he returned to America in 1804 he was elected to the Board of Directors of the American Academy of Arts; in 1817 he became the Academy's fourth president and remained in office until he resigned in 1836. Trumbull received the first major government commission for art in America; his works founded the first art gallery associated with a university – the Trumbull Gallery at Yale; his was the first published autobiography by an American artist. While not the greatest American artist of his time, his contributions to American art were more varied and more significant than those of any of his contemporaries. He died on 10 November 1843.

Art in Context

The Declaration of Independence was begun in 1786, in Paris, with the advice and information, and most probably at the suggestion of Thomas Jefferson, chief framer of the Declaration of Independence. Most of the portraits for the first, small version, now at Yale, were painted from life between 1790–93, when Trumbull was in the United States. The composition was enlarged to accommodate life-size figures for the vast Rotunda of the United States Capitol, one of four Revolutionary paintings he executed for the government between 1817–24. A third version, with figures half life-size, is at the Wadsworth Atheneum. The Declaration of Independence *expresses in visual form the ideas of the eighteenth-century Enlightenment, as those ideas were articulated in the American Declaration of Independence in 1776. The painting, together with the other scenes of the Revolution, places Trumbull at the end of the European heroic tradition, and at the beginning of the American tradition of documentary realism.*

The Viking Press New York

Trumbull: The Declaration of Independence

Irma B. Jaffe

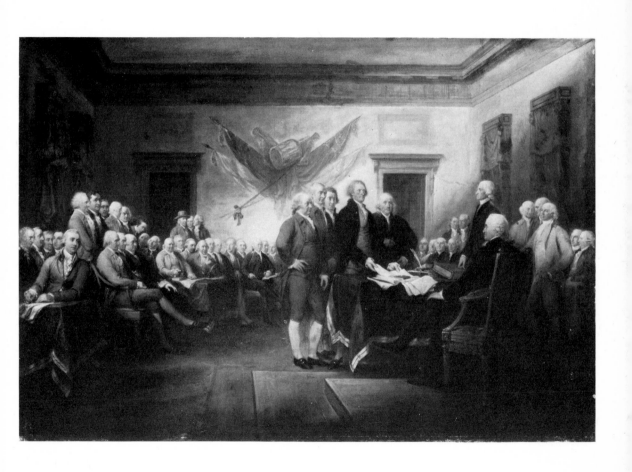

Copyright 1976 in all countries of the International Copyright Union by Irma B. Jaffe
All rights reserved
Published in 1976 by The Viking Press,
625 Madison Avenue, New York, N.Y. 10022
Filmset in Monophoto Ehrhardt by Filmtype Services Limited, Scarborough
Printed and bound in Great Britain by Butler & Tanner Ltd, Frome and London
Designed by Gerald Cinamon

Library of Congress Cataloging in Publication Data

Jaffe, Irma B
 Trumbull: the Declaration of Independence.

 Bibliography: p.
 Includes index.
 1. Trumbull, John, 1756–1843. Declaration of Independence.
ND237.T8J34 759.13 75–40174
ISBN 0–670–73264–8

For my patient family and friends

Reference color plate at end of book

Historical Table

1776–84	Declaration of Independence, 1776. Revolutionary War. Treaty of Paris, 1783.
1785–93	Washington first President of the U.S., 1789. French Revolution.
1794–99	Napoleon's Italian Campaign, 1796. Coup d'etat creates consulate with Napoleon first consul, 1799. Washington dies, 1799.
1800–09	Jeffersonian era. Napoleon defeats Russians and Austrians at Austerlitz, Nelson wins victory over French fleet at Trafalgar, 1805.
1810–15	Napoleon invades Russia, retreats with the defeated Grande Armée, 1812. Abdicates, exiled to Elba, 1814. Returns to France, defeated at Waterloo, 1815. U.S. and England at War, 1812–15.
1816–24	Bourbon restoration. Napoleon dies, 1821. Monroe president of the U.S.

TRUMBULL	ART EVENTS	
Serves in Continental Army, 1775–7. First trip to Europe, 1780–81, studies with Benjamin West. Second trip to Europe, 1784–9, studies with West.	Copley's *Watson and the Shark*, 1778, *Chatham*, 1781, *Major Peirson*, 1784. Born: Constable, 1776; Ingres, 1780; Stendhal, 1783. Died: Voltaire, Rousseau, 1778; Chardin, 1779; Diderot, 1784.	1776–84
Bunker's Hill and *Quebec*, 1786. Sketches *Declaration of Independence*, 1786. Composes *Declaration*, *Yorktown*, *Trenton*, *Princeton*, and *Saratoga*, 1787–9. Returns to U.S.	David's *Horatii*, 1785, *Socrates*, 1787, *Brutus*, 1789; Mozart's *Magic Flute*, 1790. Born: Byron, 1788; Shelley, 1792. Died: Mozart, 1791; Reynolds, 1792.	1785–93
Returns to England as John Jay's secretary on Treaty Commission, 1794. Engages in business speculations and picture dealing, 1795–9.	Goya's *Caprichos*. Born: Keats, 1795; Heine, 1797; Delacroix, 1798; Balzac, 1799.	1794–99
Marries Sarah Hope Harvey, 1800; Resumes painting. Returns to U.S. Director, then vice-president of the American Academy. Goes to England, 1809.	New York (later, American) Academy of the Fine Arts founded, 1802. Beethoven's *Fidelio*, 1805, Fifth Symphony, 1809. Goethe's *Faust* (Part I), 1808. Born: Hugo, 1802; Berlioz, 1803; Sand, 1804; Chopin, Mendelssohn, 1809. Died: Kant, 1804.	1800–09
Living in England. Returns to U.S. after war.	Byron's *Childe Harold* (Cantos I and II), 1812; Jane Austen's *Pride and Prejudice*, 1813. Born: Schumann, 1810; Liszt, 1811; Wagner, Verdi, 1813.	1810–15
Elected President of the American Academy, 1817. Commissioned to execute four paintings commemorating American Revolution, to be installed in U.S. Capitol Rotunda. *Declaration*, *Yorktown*, *Saratoga*, and *Resignation* completed in 1824.	Shelley's *Adonais*, 1821; Heine's first volume of poems, 1822. Born: Courbet, 1819; Baudelaire, 1821. Died: West, Keats, 1820; Shelley, 1822; Byron, 1824.	1816–24

1. John Trumbull of Lebanon, Connecticut

On 6 February 1817 the Congress of the United States passed a resolution authorizing President James Madison to commission four paintings commemorating the history of American Independence. The artist designated to carry out this first major government art commission was John Trumbull. A few days later Trumbull and Madison talked over the question of which subjects would be most appropriate. 'We had, in the course of the Revolution, made prisoners of two entire armies, a circumstance almost without parallel,' the artist pointed out to the President: the surrender of Burgoyne and Cornwallis thus seemed to demand priority over other military subjects such as *The Death of General Warren at the Battle of Bunker's Hill*, which, however, had the commission been for eight paintings as he had hoped, he would have included. Madison agreed. 'And what for civil subjects?' he asked. 'The Declaration of Independence, of course,' Trumbull answered immediately. There was no need to explain or justify this choice. 'And what would you have for the fourth?' the President asked him. 'Sir,' the artist replied, 'I have thought that one of the highest moral lessons ever given to the world was that presented by the conduct of the Commander-in-Chief in resigning his power and commission. I would recommend, then, the *Resignation of Washington*.'[1]

Thus the four subjects were chosen; the figures were to be life-size, on canvases twelve by eighteen feet. It was evident that had there been four or forty more, *The Declaration of Independence* (Color plate and 'Durand' Key) represented to the artist and his contemporaries, as it has to posterity, the single most important work

of the group – in fact, the most significant of his career. It was the first of the four he set himself to work on as soon as the large, finely woven canvases arrived from London: Trumbull had ordered them from Thomas Brown, whose shop in Holborn Street for many years supplied London's leading painters with artists' materials. 'I have been constantly occupied with *The Declaration of Independence*, feeling the uncertainty of life & Health,' the sixty-one-year-old artist wrote Madison ten months after the contract was signed, '& considering that Subject as most interesting to the nation, as well as most decisive of my own Reputation. The universal interest which my Country feels & will ever feel in this Event – will in some degree attach to the painting which will preserve the resemblance of Forty-Seven of those Patriots to whom we owe this Memorable Act and all its glorious consequences.'[2]

First in importance as it was, however, *The Declaration of Independence* must be viewed in the context of its three companion works in the Rotunda of the United States Capitol which together form an iconographic unity. Indeed, the painting's meaning is much enriched as we come to know the artist's grand plan for a *Hall of the Revolution*, his term for the Rotunda which he envisioned as a vast frame for a series of eight stirring scenes that marked the birth of the new nation. Unfortunately, that plan was not fully realized, and it became all the more imperative to keep the complete set of the small versions of the American history series together, so that their meaning, as a whole, would not be lost. This was the motive that led eventually to Trumbull's arrangement with Yale University whereby, in exchange for an annuity of one thousand dollars for life (he was seventy-eight years old when the contract with Yale was made!) the university agreed to build a gallery to house his bequest of about one hundred paintings – of which the heart was the American series – with the provision that they would always be kept together, exhibited as a group.

But in addition to seeing *The Declaration of Independence* as part of the American history series we must also locate it in the current of

contemporary history painting. So placed, the painting wins new respect both for its author's achievement as well as for his contribution to the mainstream of western art, for it broadens our conception of the age of neo-classicism.

Furthermore, *The Declaration of Independence* must be viewed as a document of the Enlightenment. The painting embodies artistically the philosophical convictions held by the intellectual leadership of the Enlightenment which were based on the faith that the rule of reason would bring order and justice to human society. Moreover, as we shall see, it projects in visual form the American interpretation of the Enlightenment as it is reflected in the style and content of the written Declaration of Independence.

The Declaration of Independence is one of the most familiar icons of American culture. The painting in the Rotunda of the United States Capitol [1] has been viewed over the century and a half since its creation by millions of American and foreign visitors, while the small version, at the Yale University Art Gallery, superior in quality, has been illustrated in countless books and articles on American history. Few who 'know' Trumbull's *Declaration*, however, realize there are more than one – there are three, in fact – but despite the differences between them we may speak of the painting in the singular, a symbol of American aspirations as valid today as it was when it existed only as an idea in the mind of the painter, almost two hundred years ago. It is to the painter, of course, that one must go first and foremost, to account for his work, for beyond the painting's aesthetic and iconographic context, as Trumbull's *summa*, this painting must be considered in the light of the artist's life – like all lives, a complex web of thought, feeling and experience, shaped by the elusive contours of circumstance. Few artists have acted out their lives upon the great stage of history as did John Trumbull. From his youth when, in 1775, his ability to draw maps brought him to the attention of General George Washington and won for him the honor of being appointed aide-de-camp to the Commander-in-Chief of the American Revolutionary Army, to the

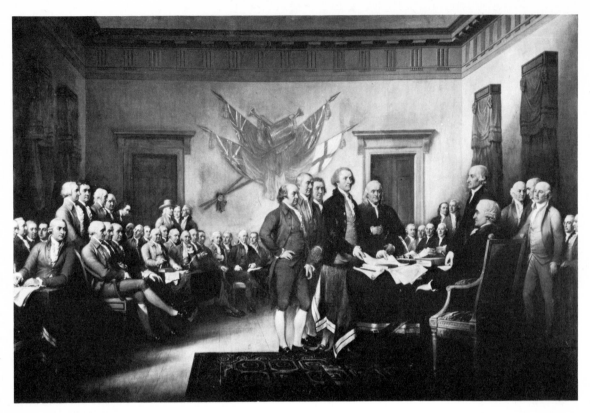

1. George Wythe, Virginia
2. William Whipple, New Hampshire
3. Josiah Bartlett, New Hampshire
4. Benjamin Harrison, Virginia
5. Thomas Lynch, South Carolina
6. Richard Henry Lee, Virginia
7. Samuel Adams, Massachusetts
8. George Clinton, New York
9. William Paca, Maryland
10. Samuel Chase, Maryland
11. Lewis Morris, New York
12. William Floyd, New York
13. Arthur Middleton, South Carolina
14. Thomas Hayward, South Carolina
15. Charles Carrol, Maryland
16. George Walton, Georgia

17. Robert Morris, Pennsylvania
18. Thomas Willing, Pennsylvania
19. Benjamin Rush, Pennsylvania
20. Elbridge Gerry, Massachusetts
21. Robert Treat Payne, Massachusetts
22. Abraham Clark, New Jersey
23. Stephen Hopkins, Rhode Island
24. William Ellery, Rhode Island
25. George Clymer, Pennsylvania
26. William Hooper, North Carolina
27. Joseph Hewes, North Carolina
28. James Wilson, Pennsylvania
29. Francis Hopkinson, New Jersey
30. John Adams, Massachusetts
31. Roger Sherman, Connecticut
32. Robert R. Livingston, New York

33. Thomas Jefferson, Virginia
34. Benjamin Franklin, Pennsylvania
35. Richard Stockton, New Jersey
36. Francis Lewis, New York
37. John Witherspoon, New Jersey
38. Samuel Huntington, Connecticut
39. William Williams, Connecticut
40. Oliver Wolcott, Connecticut
41. John Hancock, Massachusetts
42. Charles Thompson, Pennsylvania
43. George Reed, Delaware
44. John Dickinson, Delaware
45. Edward Rutledge, South Carolina
46. Thomas McKean, Pennsylvania
47. Philip Livingston, New York

1. *The Declaration of Independence*, 1818. John Trumbull (United States Capitol Rotunda)

2. The 'Mercein' key of 1826 to *The Declaration of Independence* (redrawn).
Corrections made by the author are:
No. 8 change to HOPKINS;
No. 23 change to DICKINSON;
No. 45 change to CLINTON.

threshold of old age, when, in 1826, he stood beside President John Quincy Adams in the vast Rotunda viewing the newly installed *Declaration of Independence*, *The Surrender of General Burgoyne at Saratoga*, *The Surrender of Lord Cornwallis at Yorktown*, and *The Resignation of Washington* [1, 2, 3, 4, 5, 6], his personal life and his career as an artist were closely linked to the large events and major personages of the contemporary world. As he wrote Francis B. Winthrop in 1810, 'The Military and political circumstances of my Life are so interwoven with the . . . years which I have devoted to the arts that they cannot be separated.'[3] But just as his art cannot be separated from his life, neither can the biographical facts be separated from the socio-cultural influences that pressed and shaped them, nor be removed from the matrix of personality that unpredictably broke through a highly conventional, predetermined design for living. A merchant, lawyer, minister, or public servant – these were the careers expected of a son of Jonathan Trumbull, Sr, Harvard 1727, ship-owner, merchant, and from 1769 to 1784 Governor of Connecticut.

Joseph Trumbull, Jonathan, Jr, and David followed their father's commercial interests, and later, son Jonathan even carried on his father's political profession, becoming United States Congressman, then Senator, and finally Governor of Connecticut himself. The Trumbull daughters, Faith and Mary, married Connecticut neighbors. Only the last child, John, nineteen years younger than Joseph, the first born, seemed unready to fit into the family pattern. When it was time for him to go to Harvard it turned out that he preferred to study art with a Mr John Singleton Copley in Boston. His father won the battle: he went to Harvard and graduated, class of '73; but he won the war: the first college graduate in America to become a professional artist.

During the night of 18–19 April 1775, as both history and poetry record,[4] an American silversmith, Paul Revere, raced through the Massachusetts countryside waking patriots with his cry of alarm that the redcoats were coming. Later that day, someone fired a shot

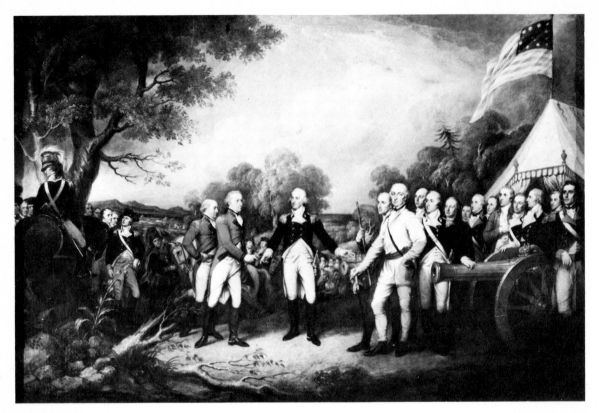

at Lexington, Massachusetts, and the Revolution had started. When the news reached Lebanon, Connecticut, a day later, the Trumbulls were ready for it. John Trumbull had spent the year after graduation teaching in the village school his father had founded, and painting, but also drilling on the village green with the local boys. He joined the Connecticut regiment of Colonel John Spencer and on 17 June 1775 was stationed at Roxbury, Massachusetts from where he could hear the guns and see the smoke and flames of the day-long battle at Bunkers Hill across Boston Bay [7].

All the Trumbulls were deeply committed to the American cause. Washington depended so heavily on Governor Trumbull's organizing abilities to provide men and material that a legend grew up around him as the original 'Brother Jonathan', an early American

3. *The Surrender of General Burgoyne at Saratoga*, 1821. John Trumbull. (United States Capitol Rotunda)

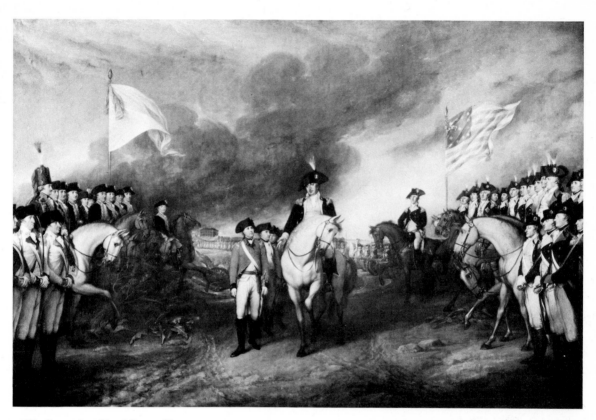

4. *The Surrender of Lord Cornwallis at Yorktown*, 1820. John Trumbull. (United States Capitol Rotunda)

5. *The Surrender of Lord Cornwallis at Yorktown*, 1787–*c*. 1828. John Trumbull

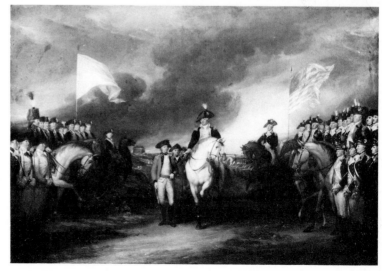

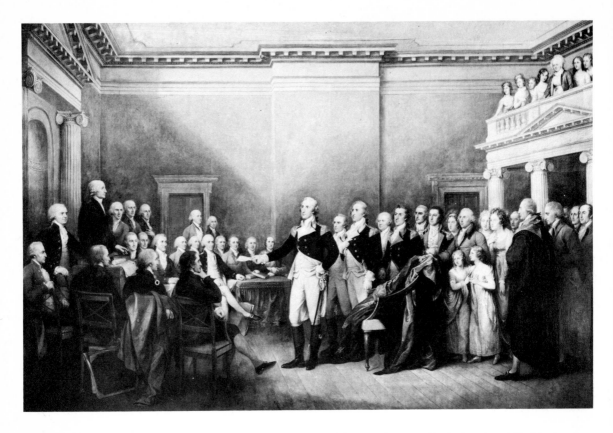

epithet for 'American', supplanted by 'Yankee': Washington is
supposed often to have remarked, when faced with difficulties, 'Let
us consult Brother Jonathan.'[5] Joseph Trumbull's early death at
the age of forty-one is attributed to exhaustion from overwork as
the first commissary-general of the Continental Army. David also
served in the commissary division, while Jonathan, Jr, held the
difficult office of Paymaster General of the Northern Department.
No wonder John Trumbull answered John Hancock's slur that the
Trumbull family was well provided for with the comment, 'He is
right; my father and his three sons are doubtless well provided for;
we are secure of four halters if we do not succeed.'[6] When the
retributive Port Act was imposed on Boston in punishment for the
now famous 'tea party', Governor Trumbull had sent relief to the

6. *The Resignation of Washington*, 1824.
John Trumbull.
(United States Capitol Rotunda)

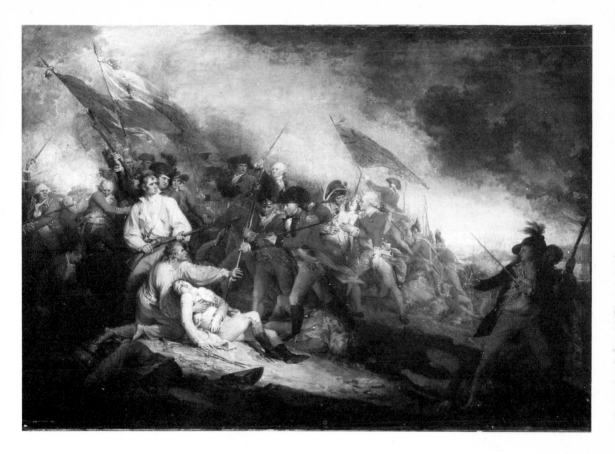

7. *The Death of General Warren at the Battle of Bunker's Hill*, 1786. John Trumbull

suffering town and ordered the Lebanon church bells to be tolled and the Town Hall to be draped in mourning as an expression of sympathy and solidarity. From his earliest childhood John had heard politics and war discussed as staple conversational fare in the family circle – enlarged by the many and constant visitors to the large, elegant Trumbull mansion. As the conflicting issues between Great Britain and the colonies deepened, the youth shared his family's militant – and moral – preparations for the crisis.

For the Trumbulls, pious Calvinists, were convinced that Providence was on the side of justice and liberty. Since American rights and freedom were threatened, the colonists surely could count on divine favor to insure the triumph of Right, they told themselves, and others. 'Whilst the designs of our enemies against us fill us with

concern,' Governor Trumbull wrote the Massachusetts Congress in 1775, 'we cannot omit to observe the smile of Providence upon us.'[7] Meanwhile it was necessary always to reaffirm one's moral commitments as a sign of living in good grace. Protestant theology had been significantly modified by the American experience so that its deterministic principle had largely given way; an individualistic rationale, vital to early colonial life, had created the need for a reward system, and public service was one of the more obvious means to earn a place in heaven – or at least to urge the claim.

Certain aspects of the eighteenth century Enlightenment – those concerned with classical antiquity as a model for the conduct of current affairs – nourished the religiously inspired ideal of public service and personal sacrifice. 'In the summer or autumn of 1774,' Trumbull recalled, 'the angry discussion between Great Britain and her colonies began to . . . give evident notice that a moral storm was at hand . . . I caught the growing enthusiasm; the characters of Brutus, of Paulus Emilius, of the Scipios, were fresh in my remembrance, and their devoted patriotism always before my eyes.'[8]

Surrounded by patriots, listening daily to the ardent expressions of Americans who were insisting on liberty or death, young Trumbull formed the attitudes that were to direct his personal life and art. Portrait painting, for all his admiration for Gilbert Stuart, for all his understanding that art has reasons that reason knows not of, portrait painting remained, for Trumbull, a frivolous activity 'little useful to Society, and unworthy of a man who has talents for more serious pursuits'.[9] History painting alone could justify the devotion of a lifetime. It was as a history painter that he intended to justify his own declaration of independence when he sailed for Europe in 1780, against the strong urging of his family to take up law or the ministry.

True he had compromised somewhat. The ostensible reason for the trip was to carry on a commercial speculation in France for his family and friends. But there is no doubt at all that he was relieved to find he had to abandon the plan for lack of sufficient international

credit. He lost no time in crossing the channel to London, and Benjamin West.

His period of study with West, however, had hardly begun when he was arrested as a suspected spy and imprisoned for about seven months in Bridewell; as a son of Jonathan Trumbull, famous as the Revolutionary governor who alone among colonial governors sided with the Americans, young Trumbull's presence in London was odious to the American royalists who had left their homes in the colonies. Trumbull claimed to believe his arrest was in reprisal for the execution of Major André, convicted for his part in the plot of Benedict Arnold to surrender West Point to the British, but it seems unlikely; there is reason to think he was involved in some anti-British adventure, but not enough evidence has emerged to clarify his role, if indeed there was such.[10] Freed on the intervention of Edmund Burke and the surety of West and John Singleton Copley, Trumbull returned to the United States, but as soon as the Treaty of Paris was signed in November 1783 he was ready to sail back to England and pick up his interrupted studies with Benjamin West.

His progress was rapid. 'If I chose to give myself entirely to portraits I could more than support myself,' he wrote home proudly in August, only eight months after his arrival.[11] He did not, however, choose to give himself to portraits.

Jonathan Trumbull, Sr, had distinguished himself as an American patriot and statesman; Jonathan, Jr, too, was clearly on his way to a position of leadership in the new nation, while David seemed assured of a life as a successful merchant. John had risen to the rank of Colonel during his period of service in the war but had resigned from the army in a huff over a misdated commission which he construed as an insult. His ambitious nature, however, his determination to stand out from the crowd, his zeal for honor (he never relinquished the title of Colonel) was deep-rooted, evident from his childhood recollections of how his imagination was stirred as he read the names of Praxiteles, Phidias and Apelles. Honor and glory could be won as an artist, he knew, and he had no intention of living

in the shadow of his father and brothers, whose talents were quite different from his. There are many clues to suggest the youngest son's sense of competition with the older males in the family. 'I graduated without applause, *for I was not a speaker*,' he stressed in his *Autobiography*,[12] somewhat puzzling until one finds in biographical accounts of Jonathan Trumbull, Jr, that *he* graduated from Harvard in 1759 as salutatorian, and when he received his M.A. three years later he delivered the valedictory speech. In later life he became well known for his oratorical talents. When John Trumbull

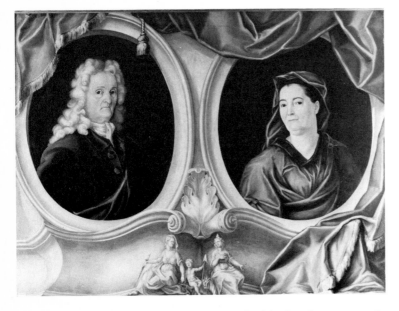

8. *Jonathan and Mrs Jonathan Trumbull, Sr,* 1774–5. John Trumbull

asked his brothers for financial aid to stake his first investment in having engravings made from his history paintings – a costly undertaking – he was hurt at their refusal on grounds of financial 'embarrassments'. He wrote Jonathan with evident irony, justifying his choice of profession: 'for if you and my Brothers who already possess Estates find a difficulty in doing any business which shall improve them, what prospect could I have? I am educated to . . . that which I now pursue here, which would not answer with you respectably, but [which] with a little perseverance gives me every

prospect of future Ease with Reputation.'[13] His satisfaction in being able to write such a letter is hardly concealed.

Trumbull's already famous father, however, was the most important influence on his life. In an early *Self Portrait*[14] he placed himself exactly in the pose he had given his father in a double portrait of his parents the same year [8] and even tried to imitate his father's expression, which sits rather comically on the face of the eighteen-year-old youth. His first history painting executed in England, aside from a copy of West's *Battle of La Hogue* which was commissioned by his teacher, was *Priam Returning with the Body of*

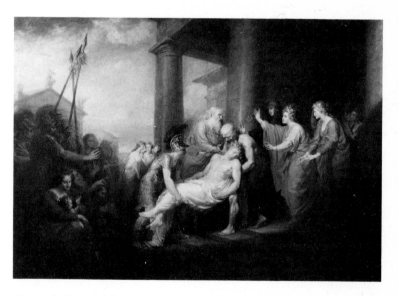

9. *Priam Returning with the Body of Hector*, 1785. John Trumbull

Hector [9] in which we may see a veiled but significant reference to his anxieties in 1784 and 1785. In letter after letter, Trumbull alludes to his stay in England as an exile from the country and family he so loved. While he was undoubtedly lonely and homesick, the letters strongly suggest a sense of guilt at having gone against the family wishes, guilt at being away so long – he would be gone much longer, it now appeared than at first contemplated – guilt at living in a world of splendor and luxury, or on the edge of it, at any rate. 'All that pomp with which I am surrounded sinks into contempt when

compared with the rational manner of life at Lebanon,' he wrote them. He was at pains to assure the family over and over again that he was not idling away his time. 'I long to be with you – Dissipation & noise and Hurry destroy all Friendship & all sober thoughts – I study night and day that I may sooner escape from a country and manners which are my aversion.'[15]

His worry could only have increased when he read his brother Jonathan's letter of 10 December 1784 with reference to the Governor, who had retired in May. 'His mind dwells much on his absent son,' Jonathan wrote, '& the longing of his heart is that he may live to see him once more returned to his fond embraces.' The family understood the necessity for his staying abroad long enough to master his profession, but they were anxious for his return. 'Time passeth, yet it looks long to Autumn come twelve months for your return,' his father wrote, 'I acquiesce in what may be for your advantage [and] wish you to acquire *the most in your line that you can*, as you will never return to Europe after your next leaving it.'[16]

That Trumbull associated his father's health with his own is suggested by the juxtaposition of ideas in the artist's letter to his father on hearing of his retirement. 'I only fear that after such an habit of perpetual business as you have lived in your health should suffer from the new ease of retirement . . . lest my health should suffer from a quite contrary cause (for I find unremitting attention necessary) I have removed from my old lodgings in D[?] Street to Paddington Square . . . the distance is a pleasant clean walk of 20 minutes from Mr West's.'[17]

It is in this context that we must view Trumbull's choice at this time of *Priam Returning*. In fact, he had also considered painting *Priam in the Tent of Achilles*, the father come to plead for the son's return, for which he made a sketch in 1785. The news of the Governor's retirement which reached him in December doubtless heightened his realization that his father was ageing; he could well have feared Jonathan, Sr, might die while he was still in England. Was he then substituting himself, the son, for Hector, and reversing

the roles, expressing the fear not that he would be brought home dead, but that he would return to find his father dead? Indeed, Trumbull's identification with his father may be seen as a primary if unconscious factor in his choice of subject matter for the most important work of his life, *The Declaration of Independence*, together with the other paintings in his American history series.

The Governor had begun a history of the Revolution, although he had completed only the introduction, according to the Marquis de Chastellux who read it and found it 'rather superficial, and by no means free from partiality . . .' He had amassed a vast collection of letters and documents of all kinds pertaining to New England and the Revolution, and his son John urged him to have them put into order with a view to presenting them to Yale College. 'Papers of this kind . . . should be regarded as the property of the community & deposited where access can be had to them, & where their preservation will be attended to', Trumbull wrote to his father, 'Yours particularly are most valuable materials for future historians.' Turning then to his own affairs he revealed a significant association of ideas as he wrote, 'The History of America, the Revolution Particularly is the object of my wishes.' The following year he wrote his friend Andrew Elliot, 'I am now . . . employed writing in my language, the History of our Country.'[18] Curiously, it was John Trumbull's 'history' of the Revolution, not his father's, as he suggested, that went eventually to Yale.

The overriding preoccupation of American thought during the second half of the eighteenth century was its concern for republican virtue. Books, articles and speech after speech took up the theme, but no verbal statement makes as vivid to our present-day imagination the meaning of republican virtue – its peculiar compound of elitism and middle-class egalitarianism; of individualism and insistence on restraint of the individual for the *res publica*, the public good; of secularism and the sturdy belief in a providential Deity; of respect for traditional values, and readiness for Revolution – as does *The Declaration of Independence*, as we will come to see. John

Trumbull's mind was formed in the very years that the notion of republican virtue was emerging as a major element in American thought. His growing consciousness of his mission as an artist coincided exactly with the nation's developing sense of consciousness of its mission as a republic.

At the core of the ideal of republican virtue lay two conceptions, that of liberty as the right of responsible men to direct their own destinies, for it was self-evident that responsible acts could only be performed in a context of freedom of choice, and the twin but conflicting notion of the right of government to exact service even at the cost of personal sacrifice of liberty and life itself. These motifs, liberty and public service were interwoven not only in countless sermons and public debates but appeared repeatedly in the private correspondence of every leader of the new republic, for it was well known that of all forms of government, republics were the most fragile; constant vigilance was needed to recognize the warnings of decay, when the precarious balance between individual freedom and the rights of government might be upset.

The problem, of course, was how to reconcile the two, and in the early republic, the greatest danger was often seen to come from too much liberty. Frequently the argument circled back on itself, as in John Warren's typical oration delivered in Boston on 4 July 1783. 'Virtue is the true principle of republican governments,' he declared. The heart of the principle, he went on to argue, was public spirit. 'From *public* spirit proceeds almost every other virtue. The man who willingly would die to save his country, would surely sacrifice his fortunes and possessions, to secure her peace and happiness.' But the object of public virtue was to safeguard the liberties of the members of the community, from which it followed that every man must be permitted to pursue those measures that would bring him his personal rewards, and thus place him, if successful, in a position of affluence 'the encouragement of which is undoubtedly the duty of the Commonwealth . . .' Thus does wealth grow, and bring with it the taste for luxury which then undermines virtue and destroys the

Republic! 'The introduction of wealth in the Roman republic, is dated at the conquest of Antiochus the Great, and the era of corruption from the same memorable period,' Warren reminded his listeners. Greece, too, fell to ruin among the splendors that wealth had brought, as her citizens forgot their virtuous heritage in their licentious enjoyment of luxury. As if stating a law of nature, Warren proclaimed the law of republics: 'the loss of public virtue is an infallible mark of real, or approaching declension.'[19]

John Trumbull was as concerned as any of his countrymen about the moral climate of the new nation, and feared prosperity as much as he hoped for it. The splendid architecture, the signs of public and private opulence he saw everywhere around him in England deepened his anxiety as he also came to know the gossip and scandal that riddled the lives of the great and wealthy there. 'The fatal consequences of Luxury and Wealth are painted before me in such melancholy scenes that I cannot but wish my country to remain poor,' he wrote. Simple comforts were enough, he told his brothers; America must not follow the materialist path of Europe, although she seemed intent on doing so. 'Have we not too eager a spirit for commerce, have we not too much ambition for Opulence, and are we not precipitating ourselves into the imitation of every species of Luxury and refinement – and does not all this tend to the inevitable destruction of republican Virtue and national Character! I fear so,' he confessed.[20]

His personal virtue was compromised, he saw, as long as he continued to paint portraits for a living, and sometimes he laughed bitterly at his own pretensions as well as others. 'It appears to me a very ridiculous world & perhaps we are not the least ridiculous objects in it,' he wrote his brother Jonathan who in 1784 was trying, with David, to rebuild the long-faltering family business. 'You talking of Economy, republican Virtue, & national Honor, & yet feeding Folly, Luxury, & Extravagance with Gauze, Ribbons & Tea – While I rail at Vanity & yet live by flattering it.' To take up, as his life's work as an artist, the painting of scenes from the

American Revolution, and sell engravings from them, suggested to him by Benjamin West, was the only way out of his moral dilemma. As he wrote Jonathan, referring to the newly planned series, 'If I do succeed, it makes me master of my time & disengages me from all the trumpery & caprice & nonsense of mere copying faces & places me the servant not of Vanity but Virtue.'[21]

West would undoubtedly have painted a series about the American Revolution himself were it not for his close association with George III; under the circumstances it would have been not only tactless but foolish – he would have utterly compromised his position as the King's favorite painter and confidant. It is fortunate indeed that he turned the project over to his gifted pupil whose military knowledge, experience and acquaintance with the men and events depicted would give his paintings a spirit and authenticity that no man living could match. Trumbull knew the look of the British and American soldiers and officers in the war; stories of hand-to-hand combat were recounted to him by officer comrades who had participated in the great battles. His illustrious name, Trumbull, and his personal qualities of intelligence, wit and charm put him on easy terms of friendship with those who founded the civil history of America; there would be no difficulty in getting portraits. West surely had these circumstances in mind when he first broached the subject to Trumbull. But, in addition, relations were strained between him and John Singleton Copley ever since 1783 when the latter had won the commission offered by the Court of Common Council in London to paint a scene celebrating the lifting of the siege of Gibraltar. As Mrs Papendiek observed in her *Court and Private Life in the Time of Queen Charlotte*, West was 'the friend of no one who might possibly interfere with his success'. He might have enjoyed the prospect of creating, as he thought, a rival to Copley whom he, West, could control. Thus, by November 1784, Trumbull's eyes were turned toward 'the great Events of the revolution,' as he wrote his brother Jonathan, 'Mr West has mentioned my doing this but it is not wholly agreed upon.'[22]

There was yet another factor that entered into shaping John Trumbull's career as a painter of American history and subtly influenced the kind of composition he chose for *The Declaration of Independence*. He was a New England Gentleman. Exalting rugged, native American gentility over effete, European, Chesterfieldian polish, the tradition was rooted in Puritan theocracy which, weakened by the middle of the eighteenth century, nevertheless still provided fundamental assumptions that supported an upper class rationale.[23] The gentleman was recognized by his social, political and economic superiority, which was derived from Providence; the superiority that was at once a warrant of his virtue and also gave him his ability to lead his fellows was a divine gift. Trumbull's vision for America, expressed in *The Declaration of Independence* – a vision generally shared by the Founding Fathers, 'Fathers' indeed because of the Puritan theocratic conceptions of leadership – was a vision of a nation governed beneficently by an upper class, a privileged, elite community of gentlemen. At Harvard, and a few years later in Boston, Trumbull's friends were college-educated New England gentlemen who were to become the statesmen, lawyers and educators of the new republic. Since Trumbull's nature led him into art, he had somehow to accommodate the gentlemanly imperative placed on him by his birth with the career he chose: if not a leader of men within the conventional meaning of the term, he had to extend its meaning in order to maintain his status and ultimately, of course, to save his soul. His art had to be brought into the category of good works which won the respect of the community at large and thus gave evidence of Providence's favor.

The gentlemanly tradition trained those born into it to appreciate and patronize the arts. To practice art was altogether a different matter. ''Twas never thought unworthy of a Gentleman to be master of the Theory of Painting,' Jonathan Richardson observed in 1715, attempting to break down the prejudice, ''Tis strange if the same Gentleman should forfeit his character and commence Mechanik, if he added Bodily Excellence, and was capable of *making*, as well

as of judging, of a Picture.' At issue clearly was the introduction of money into the transaction, for though a gentleman might 'paint for his Pleasure without any Reward . . . to make a profession of . . . this Labour . . . is the dishonourable Circumstance, this being a sort of letting himself to hire.'[24] Only if his painting were recognized as a public service could Trumbull feel comfortable in the gentlemanly role into which he was cast by fortune. For even though he would be paid for his labor, he was born into the same class as the soldiers and statesmen he portrayed in his American history pictures. He would win his right to his place in their company, as every man had to do, by virtue of his own exertions.

2. History Painting

In a sense the 'eighteenth century' can be said to have begun in 1715 with the death of Louis XIV and to have ended in 1789 with the French Revolution. Such a view makes of those intervening seventy-four years a period of transition from the past to modern times. And indeed the literature and the paintings of those decades, especially those following 1750 – one thinks of such major works as Edward Gibbon's *Decline and Fall of the Roman Empire*, of innumerable elegiac and melancholy poems, and of the countless death scenes and scenes of parting that characterize the visual arts – give one the impression that the century recognized it was saying farewell to an unrecoverable age, and felt impelled somehow to express its sense that something was at an end. Even the dainty frivolity of the Rococo years in the early part of the period had its own kind of ghostly transparency and transience, for the glowing, pink cheeked complexions could not last any more than youth, the crisp frills and bows of fashion had to become limp and hang loose.

It was the world of religious faith that was dying as the new scientific cosmos penetrated and conquered the human imagination. But like many invaders, it, too, absorbed the customs and beliefs of the conquered into its own system. Religious symbols became transformed into secular analogues, while science itself was shaped by the habits of faith and the need to believe. Thus, while Pietàs, Lamentations, and Depositions disappeared from the repertory of major mainstream painting, the death of the hero took their place, a hero surrounded by aides and friends who now peopled the secular imagination as the saints had occupied the religious one. Religious

zeal became moral fervor, spiritual illumination became rational Enlightenment, and salvation had to share first place with honor in the hierarchy of values. Far away and remote in time, in classical Athens and Rome were located the moral heaven and its heroes who provided ideal models of virtuous conduct for the here-and-now. It is no wonder that the muscular art of the age of neo-classicism was well-larded with romantic sentiment.

With the scientific spirit abroad, bringing into prominence its methodology of experiment and observation, it was to be expected that realism, too, would find expression in the arts of the eighteenth century. If the melancholy and sense of departure of the latter decades are adumbrated by Watteau in the early years, so is the neo-classical concern with realism and accurate detail found before mid-century in Hogarth and Chardin. As never before in a single period, the decades from 1750 to 1789 were charged with a complexity of conflicting stylistic tendencies – neo-classicism, romanticism, and realism – in which, nevertheless, may be found the common denominator and transcending concept of virtue.

Curiously, Republican virtue in America which stemmed from the sober traditions of Dutch and English mercantile classes, and transcendental virtue in Europe which grew out of an aristocratic chivalrous tradition, both found inspiration in the Enlightenment's interpretation of classical antiquity. It is all the more amazing to consider the direction which American virtue painting took in the hands of West, Copley and Trumbull, in contrast to that of European virtue painting in the hands, quintessentially, of Jacques-Louis David.

West's Italian sojourn had made him a bona fide member of the international set that was reforming art under the influence of the rediscoveries of Pompeii and Herculaneum, and the leadership of Johann Winckelmann. Yet, despite his success with such paintings as *Agrippina Landing at Brundisium with the Ashes of Germanicus* (1766) and *The Departure of Regulus* (1767), he took it into his head to confront the art establishment in 1771 with the then heretical *Death*

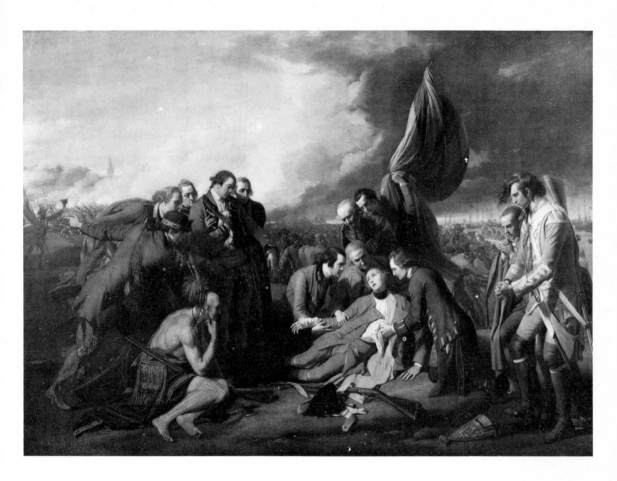

10. *The Death of Wolfe*, 1771.
Benjamin West

of Wolfe [10], a modern subject in contemporary dress. Sir Joshua
Reynolds and the Archbishop of York were shocked when they
visited West during the early stages of his work on *Wolfe* and urged
him 'to adopt the classic costumes of antiquity, as much more
becoming the inherent greatness of [the] subject than the modern
garb of war.' The American, however, had been a commonsense
colonial before he had become a classicizing artist. If the deeds of
classical heroes were appropriately celebrated in classical surround-
ings and costume, then it followed that the deeds of modern heroes
had to be celebrated in modern surroundings in the costumes of
their own time. The trouble was, according to Reynolds and pre-

vailing theory, that great deeds and heroes, like miracles and saints, belonged to the past. But West had come from a country that had no past. 'I want to mark the date, the place, and the parties engaged in the event,' he told his distinguished visitors. 'The event . . . took place on the 13th of September, 1758, in a region of the world unknown to the Greeks and Romans, and at a period of time when no such nations, nor heroes in their costume any longer existed . . . the same truth that guides the pen of the historian should govern the pencil of the artist,' he argued. Sir Joshua and the Archbishop left unconvinced but when they returned to see the finished painting Reynolds retracted his objections and pronounced his judgment that the painting would occasion a revolution in art.[25]

The account we have of this confrontation and victory comes from the hero of the encounter himself, who described it to his biographer, John Galt. Nevertheless, the story is acceptable in essence if not in exact detail and verbatim dialogue. For while it is true that contemporary events in contemporary dress had been painted ever since the Renaissance, this kind of realism had been so long out of favor under the idealizing pressure of classical academic theory developed on the continent that West may properly be credited in the light of history, as he was in his own time, with leading a revolution in history painting. A distinguished contemporary of West, Giuseppe Baretti, reflects the judgment of his peers when he remarks, 'the Art and the artists are greatly indebted to Mr West for having been one of the first who opened the eyes of the English to the merit of Modern Historical Painting, and excited in them a desire of seeing it flourish in this happy island.'[26]

John Trumbull gives full credit to his teacher as the prime innovator in modern history painting. Contemplating his projected American series, he observed that 'West's pictures are almost the only examples in Art of that particular style which is necessary to me – pictures of modern times and manners. In almost every other instance the art has been confined to the History, Dresses, Customs, etc. of antiquity.' On 18 January 1785, writing home on the first

anniversary of his arrival in London, and confiding proudly that 'the difficulties and labour of my profession begin to wear off as I acquire more practice and knowledge,' he goes on to remark that 'there is a line, untrodden in any eminent degree but by one man which offers me . . . easy & elegant support if I can acquire the necessary powers of execution.'[27] He was referring again to West and the plan for the American history group.

Strangely, Trumbull does not mention John Singleton Copley as a fellow practitioner in the revolutionary revival of group portraiture applied to history painting in a modern setting. Copley's long training in realist portraiture in America, his colonial sense of

11. *The Death of Chatham*, 1781. John Singleton Copley

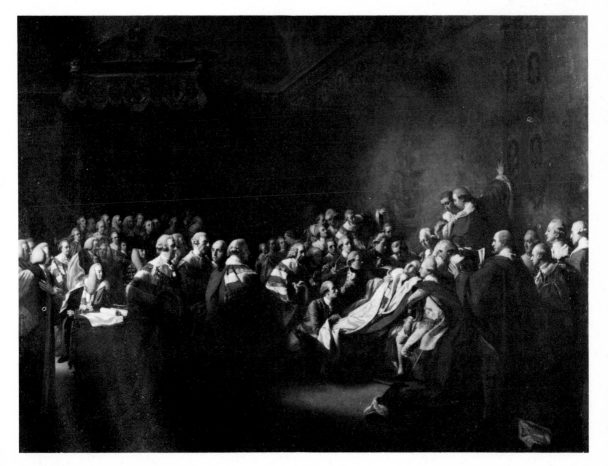

respect for the present unencumbered by reverence for the past had prepared him to pick up the clues from West's *Wolfe*. When William Pitt, Earl of Chatham, died in 1778, a month after collapsing on the floor of Parliament while protesting a Whig move to recognize American independence, the artist immediately realized he had the subject he needed to compete with West for national attention. Three years later *The Death of Chatham* [11] was finished and proved to be an enormous public success. The portraits from life and the realistic setting of the House of Lords gave to viewers a sense of being onlookers at a dramatic moment in history, an agreeable experience to those who were in fact familiar with the scene as well as to those who were not. Never mind that the ceremonial red robes were not in fact worn during debate; that the vantage point from which it is supposed the scene is viewed was a physical impossibility; that Pitt did not die on the spot as the title states; that the scene is an imagined reconstruction of the shocking event, stagemanaged for clarity and heightened effect by an artist who assumed his right to pictorial licence. The painting was sensationally convincing.[28]

In 1784 Copley exhibited *The Death of Major Peirson* [12] which celebrates the heroism of a young officer who won national though posthumous acclaim when he died in the successful defense of the British held island of Jersey in 1781 against an attempted French invasion. His success with this work was at least as great as it was with *Chatham*.

It is difficult, in the twentieth century, with eyes and minds that take for granted realistic representations in naturalistic settings, to understand the impact of such scenes in their own time. The situation is somewhat like the revolution that took place in film-making after the Second World War, when shooting 'on location' virtually supplanted filming on constructed studio sets. One hardly remembers, now, the attraction of movies whose principal advertising appeal was that they were filmed in the real world, and the fascination one felt at recognizing the actual landmarks of Paris and Rome, if one had been there, or the exotic sensation of seeing a part of the

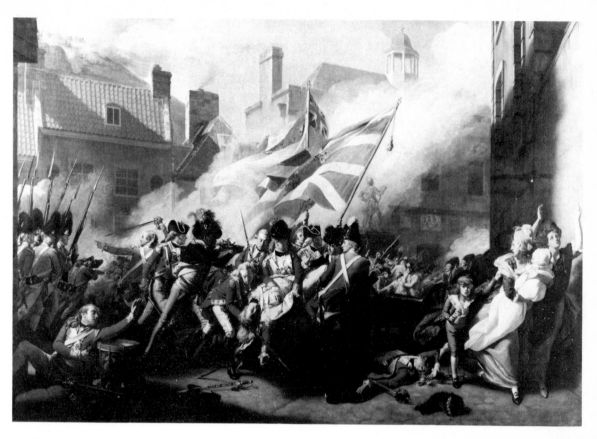

12. *The Death of Major Peirson*, 1784.
John Singleton Copley

world one had never visited. Today old movies look quaint and often laughable with their repeated shots of an 'Italian' church in the background, or a 'Russian village', although in their time they were acceptable without question and indeed looked 'real' enough. But there is an important difference between the development of naturalism in movie-making and in late-eighteenth-century painting. In the 1940s there was no philosophical restraint on the innovations made possible by technology and demanded by an increasingly sophisticated audience with a taste for experiencing 'authentic' effects. In the time of West, Copley and Trumbull, the entire moral framework of art was challenged.

Traditionally it had been assumed that the purposes of poetry and painting were to delight and instruct, and the sensuous and cerebral

were closely linked: instruction was taken to mean the imparting of worthwhile knowledge, which in turn was defined as knowledge that ennobled the knower. Pleasure accompanied this kind of knowledge naturally, it seemed, for surely there could be no real pleasure in sordid or trivial knowledge. It followed that great subjects were required as vehicles to carry such knowledge that pleased and instructed on the highest level of art, and great subjects were those that had stood the test of time and universal significance, a test that contemporary events with their emphasis on the factual were unable to meet, in the opinion of many leading artists and theoreticians. Robert Anthony Bromley could attack Copley as late as 1794 for concerning himself with matters of fact, for facts belonged to the everyday world of experience and had a relatively inconsequential place on the scale of eternal values.[29] The Americans, however, were using a different system of weights and measures.

Art in America had not descended from papal and royal courts; it had not yet served a public function or a princely ambition. In Europe the uses of art to glorify religion or the state had produced a huge body of theory which so obscured it from nature that only a genius arising from time to time could re-establish contact with the world of phenomena. In America it is likely the first drawings were rudely made maps, marking out and dividing up the new land. Usefulness as a prime motivation in early American colonial life has perhaps been overstressed in our critical literature; the colonists came, after all, with spiritual needs and intellectual ideals – but they landed on a rocky coast. Facts had to be dealt with at first hand, and facts have remained extraordinarily interesting to Americans. The habit of factual recording came early to American artists who were called upon to paint likenesses, usually of persons although sometimes a landowner was proud enough of his house and property to want a record of how it looked, too. Factualism was the first and only art style for which there was any demand in the colonies; anglicizing embellishments were welcome additions if the itinerant limner happened to be up to it. Removed from high culture, produced out

of the habit of unreflective immediacy, and with no critical apparatus to measure action against theory, bent on representing the known, early American factualism paradoxically perhaps often seems strangely suspended from reality. Its effects now seem frequently decorative and charming; that facts, in the hands of genius, could shine with beauty was first shown in America by John Singleton Copley.

Trumbull had known Copley and his work ever since his Harvard days when he visited the already famous Boston artist and found

13. *Joseph Trumbull*, 1778.
John Trumbull

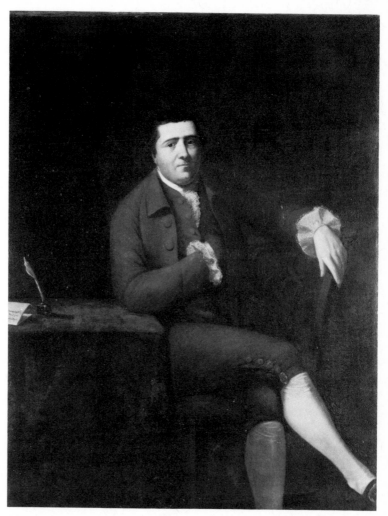

him 'an elegant looking man, dressed in a fine maroon cloth, with gilt buttons'[30] – a dazzling sight to the eighteen-year-old Lebanon boy. Copley's paintings were the first he had ever seen deserving the name, and they had certainly stimulated his desire to pursue art as a profession. Copley's influence is evident in Trumbull's early portraits [13] and remained strong in his mature work. He must have had numerous opportunities to see Copley's modern history paintings for the two artists were on friendly terms and Trumbull probably had access to Copley's painting rooms at that time; besides, *Chatham* and *Peirson* were both on exhibition during the summer of 1784.[31] One can only guess that Trumbull in his letters home omitted reference to Copley as a modern history painter for some personal reason, possibly having to do with the growing hostility between West and Copley. He not only depended on West's good will, but on his patronage: West had commissioned him in 1784 to make a copy of his *Battle of La Hogue*, and the young artist could expect his teacher to offer further commissions, as in fact, he did – in 1786 West hired Trumbull to assist him in his series of paintings for King George III at Windsor Castle. Clearly his interests lay with West. Since one could never be sure into whose hands a letter might eventually fall, it may have seemed wiser to leave Copley's name out of his correspondence altogether.

But it is evident that he did not leave Copley out of consideration when it came to planning his historical compositions. The first of these, *The Death of General Warren at the Battle of Bunker's Hill* [14], painted in the fall and winter of 1785–6, shows the influence of both compatriot artists. From West, in addition to the initial stimulus of the general subject matter, came the idea of representing the actual physical location and of memorializing with portraits some of those present. Like Wolfe, General Warren is seen slouched in the arms of a comrade [15], and the group is built up with supporting figures topped by flying banners. Technically Trumbull followed West's manner of contrasting light and shade by darkening the cast shadows along the line of intersection between light and

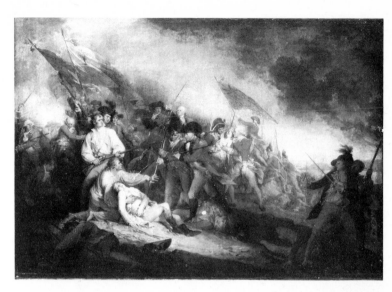

14. *The Death of General Warren at the Battle of Bunker's Hill*, 1786. John Trumbull

15. Detail of 14.

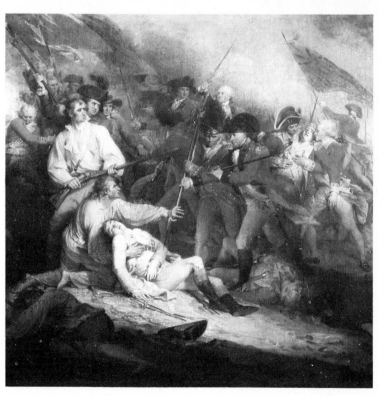

dark; like West, he used orange tints in white to warm his lights, and violet in the dark areas to cool the shadows and relieve denseness. Copley's *Peirson* seems to have suggested the two death scenes in *Bunker's Hill*, one in the foreground, the other in a subordinate plane. The Black soldier in *Peirson* possibly led Trumbull to the idea of including Peter Salem as Lieutenant Grosvenor's field-servant in the final painting; in an earlier sketch Grosvenor's companion is a white soldier. In Copley's painting, the very effective group running out of the scene at the right, with the head of the principal figure turned back towards the action, probably inspired Trumbull's group of Grosvenor and Peter Salem [16,17].

16. (*far left*) *The Death of General Warren at the Battle of Bunker's Hill*, 1786 (Detail). John Trumbull

17 (*left*). *The Death of Major Peirson*, 1784 (Detail). John Singleton Copley

Trumbull was not, however, an unthinking follower. He used West's methods and studied Copley's arrangements and poses, but the effect of *Bunker's Hill* is quite different from both *Wolfe* and *Peirson*. Trumbull's color is more vivacious than theirs; for its time, it was startling as we know from Goethe's reaction when he saw the painting in the hands of the engraver, Johann Gotthard von Müller,

in Stuttgart: '. . . for a picture in which so many red uniforms must be introduced,' he wrote Schiller, 'it is very judiciously colored. At first view, it makes a glaring impression until one becomes reconciled to it through an understanding of its real merits.'[32] Furthermore, the relationship of pictorial elements in Trumbull's work is more dynamic than in Copley's and West's. The crucial difference in effect arises from the asymmetrical design of *Bunker's Hill* as compared with the centrality of *Wolfe* and *Peirson*. That asymmetry represents a significant choice here and in other battle scenes where virtue is expressed principally in action and physical courage becomes evident when those works are contrasted to ceremonial scenes such as *The Surrender of General Burgoyne at Saratoga* or *The Surrender of Lord Cornwallis at Yorktown*, and above all, *The Declaration of Independence*. For these, in which action is suppressed, Trumbull chose a broad, frontal, symmetrical composition as a formal means appropriate to the expression of high moral purpose and characteristic of the imagery of ritual.

While prevailing critical opinion tended to be conservative, progressive aesthetic ideas that involved changing attitudes to subject matter were gaining ground. Among the formative influences that established a receptive atmosphere for contemporary history painting in the eighteenth century were the narrative series of William Hogarth together with the impact of his book, *The Analysis of Beauty*. Although Hogarth dealt with social problems rather than military and political events, and his method was satirical rather than idealizing, his purpose in his graphic stories – like that of his classicizing opponents – was to teach virtue. Attacking the conventional aesthetics of the time, he demonstrated that art need not be tied to antiquity but could, and indeed, should concern itself with modern life. Reynolds and prevailing theory might disagree, but grudging admiration had to be admitted for the painter who had applied himself to everyday reality and expressed with such precision the various shades of passion as exhibited by 'vulgar minds'.[33] Meanwhile taste had been shifting and sensibilities were slowly altered as

the eyes of artists and public alike became accustomed to the depiction of scenes from modern life.

Trumbull had checked out Hogarth's book from the library when he was a student at Harvard.[34] This he read with attention, he recalls in his *Autobiography*, but the evidence for Hogarth's fundamental influence is explicit in his *Self Portrait* painted in 1777 [18]: here he represents himself as a young artist with his palette literally supported by a copy of Hogarth's book. The palette, moreover, is arranged according to Hogarth's recommendation, red, yellow, blue, green and purple graduated from dark to light through seven shades and tints.[35] It can hardly be doubted that Trumbull was familiar with the English realist's engravings, and it appears that the fluid rhythms and the proportions of figures to the overall field in Trumbull's mature painting owe much to the style of William Hogarth. Uninhibited by formal academic teaching or apprenticeship, he was receptive to what a conventionally trained young artist might have tended to view with Reynoldsian condescension. In London a few years later, and coming under the more direct influence of West and Copley who, for all their realism had taken on a commitment to the traditional aesthetics of grandeur, Trumbull still retained his closer allegiance to naturalistic effects: there is less of the obviously staged in his history paintings than in those of West or Copley. The asymmetrical massing of figures towards the left, in *Bunker's Hill*, the highly activated poses, the prominent position of un-uniformed American militiamen are in marked contrast to the triptych-like division and posed display found in *Wolfe* and *Peirson*, and are farther removed from such high Renaissance sources as are evoked by the Michelangelesque *Wolfe*, for example, or the Raphaelesque group at the right of *Peirson* that recalls the Aeneas, Anchises and Ascanius group at the left of *Fire in the Borgo*. Not that Trumbull ignored traditional sources. He pored over engravings after the Old Masters, and after the sculptural reliefs that decorated the architectural monuments of ancient Rome. He drew from casts in the Royal Academy, as every student was trained to do. The fallen

18. *Self Portrait*, 1777.
John Trumbull

soldier at Lieutenant Grosvenor's feet seems to be quoted from Raphael's *Heliodorus*. General Putnam recalls the *Borghese Warrior*, while General Small suggests Giambologna's flying *Mercury*, both of which were in the Academy's collection.[36] The pose of Grosvenor is reminiscent of the fleeing son of Niobe in the Uffizi, although Trumbull's source for the figure is not clear; there was no cast of this Niobid in the Academy, but drawings of such figures were not hard to come by.

Nevertheless, the use Trumbull makes of his sources creates a more life-like impression of the over-all scene. Even in ceremonial depictions of surrender, and in the *Declaration of Independence* where a central axis and symmetrical design support the requirements of formality, he contrives either by the setting, or costumes, or proportions of the figures to the picture space – singly or in combination – to impart a sense of happening rather than of re-enactment [19, 20]. What Trumbull brought to modern history painting was the language of American prose, direct, unembellished, depending on effects of spontaneity and immediacy. He took over from West and Copley their revolutionary attitude towards subject matter, but not their conservative rhetoric.

Trumbull, it may be remembered, was twenty-eight years old when he began seriously to study the language of high art. By contrast, West was twenty-two, and had gone to Italy where neo-classical reform was a new and inspiring moral aesthetic, articulated at its intellectual center by Johann Winckelmann. When Copley left America on the eve of the Revolution at the age of thirty-seven, his was both a physical and a psychological departure. With closer ties to the Royalists than to the Patriots, and with no personal sense of nationalism, he sought to make himself an Englishman in England so that no touch of 'rebel American' could keep potential clients away. Trumbull, on the contrary, belonged to a famous Patriot family and despite close friendships formed in England, and even after many years of living abroad, he continued to feel himself a stranger out of his native land. Angry over what he considered the

19. *The Declaration of Independence*, 1787–1820 (Detail). John Trumbull

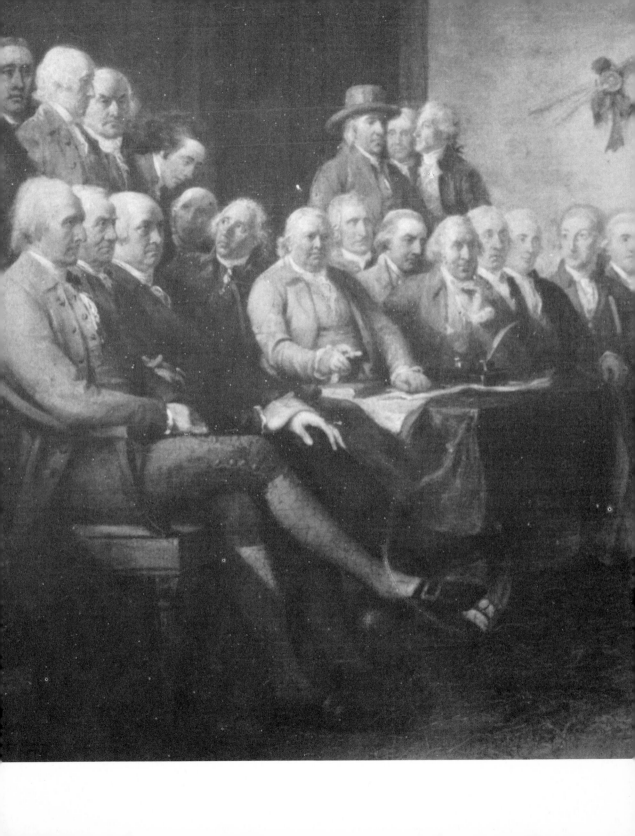

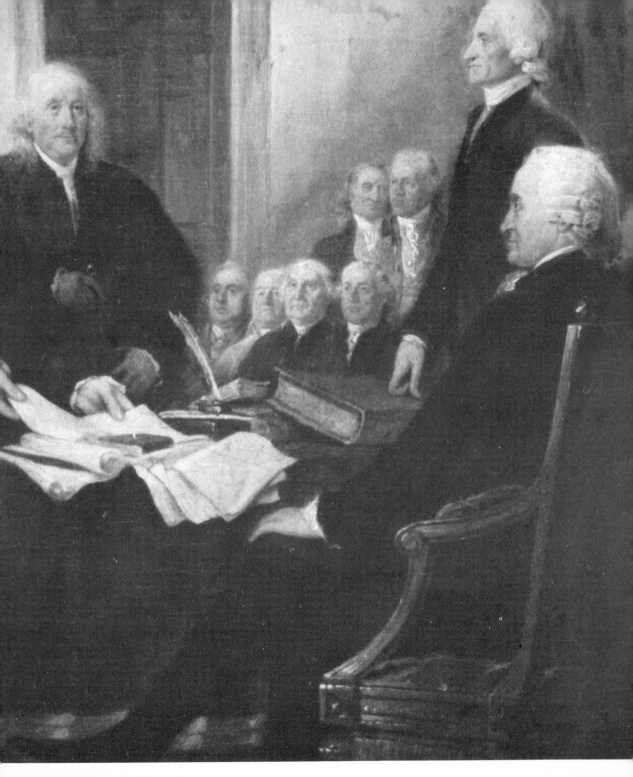

20. *The Declaration of Independence,*
1787–1820 (Detail). John Trumbull

mistaken policies of his government in 1811, policies that had seriously damaged his family's business and his own career, he was nevertheless appalled when his illegitimate son, John Trumbull Ray, known as his 'nephew', wanted to join the British army. 'America with all her follies is still my Country & yours,' he wrote the young man. 'We are both *Aliens* in every other.'[37] He was never more than superficially an anglicized American and the mental habits formed in his youth dominated his artistic vision. True virtue needed no adornments; true elegance was simplicity itself.

Not particularly constant in his political and social relationships – although devoted to a few life-long friends like Christopher Gore and Rufus King – opportunistic, at times, to serve himself in his profession, Trumbull expressed his aesthetic convictions with remarkable consistency in his style of dress and speech, his architectural designs, his *Autobiography*, and his painting. His nephew-in-law, the distinguished scientist Benjamin Silliman, recalled in unpublished biographical notes written fourteen years after the artist's death:

'Many strangers both American and foreign called to pay their respects to him, as well as to know, personally, so distinguished a man, and were always delighted by his affability and kindness, and instructed by his intelligence & wisdom. His manners were at once dignified, affable and attractive, and an elegant simplicity both in word and action placed his visitors at ease . . . He was remarkable for the simple neatness of his apparel . . . partial to grey mixed cloth or to other plain colors, coat & pantaloons being of the same material – vest of some lighter color & fabric . . . the impression of elegance and gracefulness which he made upon society was due to his finished manners and not to any adornments of costume . . . In travelling . . . his baggage was usually a carpet bag – an umbrella & a great coat or at most a very small trunk . . . The simple equipage of the camp such as he had used in military service . . . were commonly all that he desired . . . [his] was a very plain, simple & direct address, without flourishing language . . . united with a frank and cordial greeting which gave assurance to a modest visitor.'[38]

When it came to designing the Trumbull Gallery in New Haven, Connecticut, in 1831 [21], Trumbull was drawn to the severe Greek

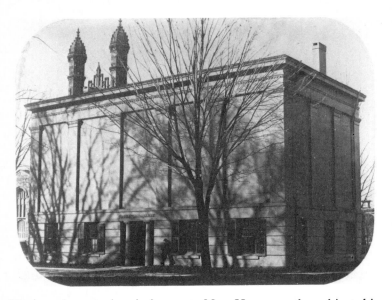

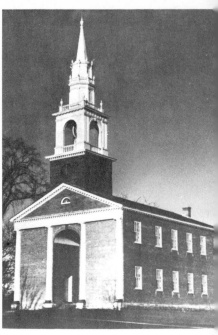

Doric style, stressing, in letters to New Haven on the subject, his desire for simplicity. The way the columns are engaged in the plane of the façade of this building emphasizes the fundamental box-like nature of architecture as enclosure, on a highly reductive level. In the only extant building designed by Trumbull, the Meeting-house at Lebanon [22] built in 1804 and restored in 1954 in accordance with Trumbull's plans, we see a compression and simplification of Christopher Wren and James Gibbs in the handling of the steeple, and possibly an echo of Claude-Nicholas Ledoux's severe geometry in the façade. As for the *Autobiography*, its pages unfortunately suffer from the writer's refusal to enrich his account with more personal feeling and reflection, as if he feared such subjective embellishments might compromise the book's factual tone. Simplicity and elegance were the overriding aesthetic concerns of the man who painted *The Declaration of Independence*.

The reforming nature of late-eighteenth-century art was, in its rejection of the ornamental and fanciful, in harmony with tradi-

21 (*left*). The Trumbull Gallery, New Haven, Connecticut, 1832: demolished 1901. John Trumbull

22. The Meetinghouse at Lebanon, Connecticut. 1806. John Trumbull

tional American preferences. The abstract idealism of neo-classicism, however, contrasts sharply with the kind of American taste most characteristic of its culture, the taste that would be summed up in 1835 by Ralph Waldo Emerson in his classical distillation of national feeling: 'Instead of the sublime and beautiful,' he observed of American poetry and art, 'the near, the low, the common, was explored and poetized.' Speaking for all, he declared, 'I ask not for the great, the remote, the romantic; what is doing in Italy or Arabia; what is Greek art, or Provençal minstrelsy; I embrace the common, I explore and sit at the feet of the familiar, the low. Give me insight into to-day, and you may have the antique and future worlds.'[39] Of course, in Trumbull's day and that of the Founding Fathers, the 'common' and 'low' did not have the same social meaning that had evolved by 1835 in Jacksonian America. Early Republicans and Federalists alike were elitists. They saw their role as leaders in the light of aristocratic concepts of talent: theoretically they would have admitted that anyone could rise to the top, but in practice it was observable, it seemed, that the wealthier and thus the educated were appointed by Providence to perform the tasks required of an orderly republic. Nevertheless, the cultural homogeneity that unified the American colonies and post-revolutionary republic – despite diverse and often dangerously conflicting interests – imparted a sense of common belonging within the society. The prejudices that arise from long-standing national or racial or religious antagonisms hardly existed, and without these hurdles, respect for one's fellow Americans was easy and could be accommodated smoothly with one's sense of class superiority.

John Trumbull's identification with the aristocratic class in America is evident in his painting and in no way contradicts his American realism, but the less high-born West who successfully challenged classical aesthetic theory and yet paradoxically accepted its formal demands betrays the more common mind in his modern history paintings than does Trumbull. In his *Penn's Treaty with the Indians*, for example, for all its high class pedigree descending, it

appears, from Masaccio's *Tribute Money* and poses quoted from Raphael, he chose to depict William Penn not as the moral giant who went to prison for his beliefs and who established the colony of Pennsylvania as a holy experiment in religious and political freedom, but as an English merchant overseeing a business deal with the Indians. The Chief is being offered a nice bolt of cloth in exchange for peaceful relations. West's contemporaries were distressed by the lapse in taste that permitted such indecorous anecdotal scenes as were found in *The Battle of La Hogue*. When the painting was exhibited at the Royal Academy in 1780 the London *Morning Post* objected to 'the disgraceful attitude of the French officer in the boat, and the sailor aiming a blow with his fist at a drowning man . . . a circumstance too ludicrous for the sublimity of such a composition.'[40] Trumbull, on the other hand, is less immersed in classical form, yet reveals a closer affinity to the spirit of classical ideals. In *Bunker's Hill* both American and British officers display courage and high moral conduct. General Warren has sacrificed his life, but so has Major John Pitcairn. And Major John Small is depicted attempting to deflect a bayonet aimed at his enemy Warren. Self sacrifice and generosity toward the defeated on the part of the victor constitutes standard behavior for classical heroes. A noble protagonist must have a noble adversary. The more common mind is also expressed by William Dunlap who attacked Trumbull for his handling of the scene. 'The death of Doctor Warren . . . is an incident of minor consequence compared with the repeated defeats of the veterans of Great Britain by Prescott, Putnam, and the brave undisciplined Yankee yeoman . . . Surely a moment of triumph might have been chosen by an American painter,' he complained, completely missing the point.[41]

In 1786, as he prepared to undertake *The Declaration of Independence*, Trumbull stood at the intersection where the high road of classical painting turned towards naturalism. He looked to the future and recognized the need to be patient while his audience slowly caught up with what he was doing. Americans, like Euro-

peans, were accustomed to think of painting, other than portraits, as depictions of classical scenes set in ancient times, and his modern subjects in familiar garments were as much an innovation in America as they were abroad, if not more so. Returning home in 1789 to sell subscriptions for the engravings of *Bunker's Hill* and its companion, *The Death of General Montgomery in the Attack on Quebec* [23], the second of the series, finished in the spring of 1786,

23. *The Death of General Montgomery in the Attack on Quebec*, 1786. John Trumbull

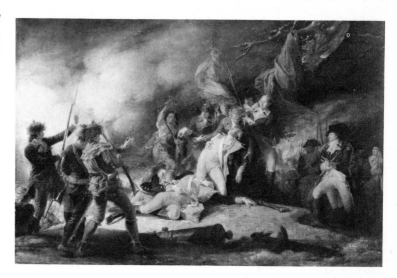

and to execute portraits from life for *The Declaration of Independence* and his other American history paintings, the artist explained, and waited, and finally was encouraged by the hopeful signs of acceptance. 'You will rejoice,' he wrote Harriet Wadsworth with whom he was in love, 'when I say that [the work] . . . becomes more popular, the more the nature & style . . . is understood . . . there is no reason to doubt but it will become equally popular in many parts of Europe . . . The patient perseverance which I have been obliged to exert & which has often been almost exhausted, will be rewarded at last.'[42] By the end of 1791 subscriptions already sold amounted to three-quarters of the expense of the engraving.

Moving forward as he did in the critical three years leading to the outbreak of the French Revolution, Trumbull carried the bag-

gage of his life experience. His achievements during those years were realized by the successful fusing of the two disparate traditions which gave him his art: provincial realism and sophisticated idealism. True, high art had its own tradition of realism, while the provincial imagination could at moments soar into the thinner air of abstract symbolism; the conditions for synthesis existed. John Trumbull achieved that synthesis in *The Declaration of Independence*.

3. *The Declaration of Independence*

With *Bunker's Hill* and *Quebec*, John Trumbull's art reached maturity. West and his other artist friends praised his work highly and it must have seemed to him that clear sailing lay ahead. His plan was to have the first two paintings engraved immediately, open subscriptions for the prints – which would defray the cost of engraving – go on with further paintings, and in a few years begin to live on the profits of the first two publications. As new paintings were finished, new subscriptions would be sold and in this way he would earn his living for many years to come. Benjamin West told him that the prints for *The Battle of La Hogue* alone had brought in about fifteen hundred guineas at one guinea each, and for a pair of engravings that cost £1,000 he had realized a profit of over £6,000. 'The Battle of Bunker's Hill – Trenton – the 7th of October – Saratoga – Yorktown &c. would certainly tempt many of our countrymen as well as Europeans,' Trumbull wrote his brother Jonathan confidently in September 1785,[43] in the light of West's experience and encouragement. Moreover, the fame of his engravings would doubtless, so it appeared, bring him commissions for other paintings as well, and he could look forward to a successful and honorable career in his chosen profession.

Looking back even now it seems that the plan should have worked. That it did not was due to a combination of circumstances entirely beyond the artist's control. What went wrong was the timing. As it turned out, the engravings were not ready for sale in America until 1799. Trumbull was not in the country then to promote the sales which therefore had to be handled by agents on commission, and

even had he been it is doubtful he could have had substantially greater success. The mood of the United States was not such as to give his Revolutionary paintings popular appeal. If they could have been presented for sale when the artist returned to America in 1789 the entire run would probably have sold out. Whatever political suspicions and enmities then lurked among the leadership in the government at that time, the country was not yet divided into the bitter opposition between Federalists and Republicans, between pro-British and pro-French partisans that made the decade of the nineties one of the most violent political periods in American history.[44] National pride in the achievement of independence was still strong, particularly in 1789 when heightened national consciousness was raised by the election and inauguration of the first President. Ten years later very different preoccupations filled the national mind. The rise of Napoleon and the consequent political and military alliances developing in Europe drew attention across the Atlantic, while the increasing penetration of the frontier attracted interest in the westward expansion of the country.

Trumbull's prints were thus offered at a moment when America was too involved in its present to be nostalgic, too conscious of its heroic future to need to invoke the memory of its heroic past. Furthermore, the earlier attraction of republicanism and revolution had lost its bloom for many, in the wake of the French Terror, and France, where Trumbull had expected to sell large numbers of prints, was no longer of a mind to be interested. 'My plan,' Trumbull wrote his friend General Lafayette, 'bore too near an affinity to passing scenes, not to be offensive to the majority of Europe; I persevered . . . in collecting materials and in advancing several compositions as long as there remained such a probability of success as could justify the sacrifice of the time and attention which were necessary for the completion of the work . . .'[45] but eventually, he explained, he had had to abandon his plan. Only one other of the American series was to be engraved, *The Declaration of Independence*, and that not until many years later.

But in 1786 the prospects justified everyone's optimism. West introduced Trumbull to Antonio di Poggi, an artist, fan decorator, and now a publisher of engravings who agreed, for a share of the profits, to undertake the business end of publishing Trumbull's prints. The first order of business, of course, was to find an engraver, which proved difficult; in England, good ones were already fully employed with commissions. Poggi suggested to Trumbull that they would be more likely to find the man they wanted in Paris, and they made plans for a trip to the continent, the publisher going on ahead to survey possibilities, while Trumbull stayed behind to finish *Quebec* and the work he was doing for Benjamin West's series at Windsor Castle narrating the triumphs of Edward III. Late in July he was ready to join Poggi, and to accept Thomas Jefferson's cordial invitation to stay with him at the Hôtel de Langeac where the American Minister to France lived during his term of duty in Paris.

Trumbull and Jefferson had met in the spring of 1786 when the latter had come to London on diplomatic business. The artist's social connections gave him easy entrée into the household of John Adams, then American Minister to Great Britain, and made introductions to other high ranking government officials a matter of course. Jefferson had formed a strong liking for the gifted artist and immediately extended his friendship and hospitality to him. The man who drafted the Declaration of Independence was customarily eager to take under his wing young Americans who were to become leaders in the new nation, to help guide their education and train them for public service. His interest in the arts, moreover, always keen, had been further stimulated in Paris, and he was evidently delighted with the prospect of having as his guest this intelligent, informed artist with whom he instantly found much in common. They discussed the aesthetic problem on Jefferson's mind at the moment – the statue of George Washington which Jean-Antoine Houdon had been commissioned to make for the state of Virginia. The sculptor was ready to start work but the question of

how Washington should be dressed for the monument had not yet been settled. Trumbull argued in favor of modern dress and, classicist though he was, Jefferson agreed that a modern hero in antique garments was as ridiculous as a Hercules or Marius in periwig and *chapeau bras*.[46] For his part, Trumbull, always attracted by erudition and acutely aware of the importance to him of Jefferson's patronage, must have looked forward with the greatest anticipation to his Paris visit. Armed with letters of introduction to various important people including Jean-Pierre Le Brun, husband of Vigée Le Brun and one of the leading art dealers and connoisseurs in the French capital, he arrived at the Hôtel de Langeac with happy expectations.

For the next four years or so Jefferson and Trumbull were close, affectionate friends. The younger man became Jefferson's trusted personal confidant (transmitting the Minister's undercover correspondence with Maria Cosway) as well as his artistic adviser. When Jefferson's art collection was auctioned in 1833 the catalogue described the works for sale as having been acquired in Paris with the help of Colonel Trumbull.[47] In 1786, and on Trumbull's next visit during the winter of 1787–8 when he again stayed at the Hôtel de Langeac, the two men frequented the same salons where the most enlightened and liberal intellectuals of France gathered. At that time Trumbull found himself in general agreement with Jefferson and his friends such as the Duc de la Rochefoucauld, the Marquis de Condorcet, Malesherbes, and the distinguished group of Abbés that included Morellet, Chalut and Arnoux. He shared their passionate belief that the great revolution they knew was coming would bring Frenchmen the same liberty the Americans so gloriously won with French assistance. He felt at home then among these elegant revolutionaries, although years later he was to look back upon those days and see himself as something of a 'Jacobin': in pre-revolutionary France, before the violence and Terror, republicanism provided a context broad enough to accommodate wide differences in political views among men who, after all, shared an aristocratic and privileged social position.

Despite differences that would eventually sharpen and bring about a break between them, Jefferson and Trumbull were both rooted in the assumptions of the Enlightenment and the traditions of American thought. Both had faith that reason, man's primary instrument in the search for truth, could discover real knowledge and lead the human race to happiness. They found in the works of antiquity the principles of order, regularity, and pattern that signified the operation of the human intellect, and they took these principles as their own guides to rational and moral order. Although ultimately Trumbull's deep-rooted Calvinist belief in Providence and Divine Wisdom would cut him off from Deist and Atheist friends, and he would come to anathemize Thomas Paine, in 1788 he painted the portrait of the author of *The Age of Reason* which he presented to their mutual friend Thomas Jefferson.

24. *The Religion of Nature* ('*And Look Thro' Nature up to Nature's God*'), 1782. John Trumbull

In common with Jefferson, Trumbull venerated Newton and Locke whose portraits he copied from an unknown source in 1774 (unlocated)[48] and fitted in his theological convictions with the religion of nature which, after all, acknowledged the existence of one God who dispenses rewards and punishments, and the obligation on all to worship him in repentant piety and virtue. It was observed that 'savages' in the newly discovered lands, although untouched by Christianity, lived in virtue and the inference was drawn that just as there were natural physical laws, as Newton showed, there was also universally present in the human heart an inborn intuition of goodness and an innate sense of moral conduct. In 1790 Trumbull's first gift to Harriet Wadsworth was a book about the uncivilized inhabitants of the Peleliu Islands who he thought she would be delighted to find, as he had, possessed 'all that cordial Hospitality & Benevolence & all the generous confidence of Friendship which forms the highest charm of our Existence.'[49] He rejected, of course, the Hobbesian conception of the universe as mechanistic [24]; as a convinced Christian he gave his commitment to that stream of rationalism that remained out of the overwhelming embrace of materialism and atheism.

Politically Trumbull was as convinced as Jefferson that ordinary men would make good and wise choices if they were properly informed. 'I find from the latest Boston papers that the tumults in that State are more quiet,' he wrote his brother in connection with Shays' rebellion. 'This *insurrection* has been the effort of a few profligate artful villains, hired to work upon the passions of the ignorant.'[50] Virtue was evidently a consequence of knowledge, these men believed with their *philosophe* friends. But the *wish* to be virtuous was thought to be a natural impulse, for men were held to be instinctively rational, and it followed that the reasoning mind was able to understand objectively the need for self-restraint even as the other natural instinct for self-interest stimulated personal acquisitiveness.

With such ideas held in common, ideas that had already flowed through Jefferson into the Declaration of Independence, the stage was set for one of the strangest, one of the most extraordinary and dramatic collaborations in the intellectual and artistic history of western civilization. It is as if the man who drafted the Magna Carta then described to a contemporary artist the scene at Runnymede when the nobles forced from King John the proclamation of their rights. For it was Jefferson, principal author of the Declaration of Independence, a major document in the long struggle to formulate concepts of human rights and regulate optimum relations between governors and governed, Jefferson it was who appears to have proposed the Declaration's visual realization to the artist who came to paint it. Trumbull's plan for the series, as he listed the projected works in his letter to Jonathan Trumbull the year before his Paris sojourn (see above, p. 59 and *n.* 43), included only the famous battles and the crucial surrenders at Saratoga and Yorktown. Not until his visit to the Hôtel de Langeac is there any reference to *The Declaration of Independence*, and although Trumbull does not specifically credit Jefferson with the suggestion, he tells us in his *Autobiography* that he began the composition with the assistance of Jefferson's information and advice while a guest at the American Minister's

25. *The Declaration of Independence.*
Plan of the Assembly Room
(Independence Hall) by Thomas
Jefferson; first idea of the
Composition by John Trumbull, 1786

home in Paris.[51] Moreover, the very first sketch of the composition is on one-half of a sheet of drawing paper on the other half of which is a rough sketch of the Assembly Room, drawn by Jefferson in Paris in 1786 'to convey an Idea of the Room in which congress sat, at the Declaration of Independence on the ground floor of the old State House in Philadelphia – left hand at entering.' [25].

Strangely, in view of his architectural knowledge and sensitivity, Jefferson's memory of that historic room was faulty. The room is indeed off to the left, east of the central entrance of the State House,

but curiously his sketch indicated the west wall with an entrance near the north end and a symbol probably meant to indicate a closet near the south end. It was the east wall that had two doors, one leading into a closet near the north end, the other leading in and out of the room near the south end. The west wall, the one shown in *The Declaration of Independence*, had only one door, placed at the center [26]. Jefferson also omitted to show two fireplaces flanking a central tabernacle on the east wall in front of which was the dais. He apparently forgot the room was decorated in Ionic style and that the doors were pedimented, for we must assume Trumbull's Doric ordin-

26. Independence Hall: the west wall (restored 1960s)

nance was painted on the basis of Jefferson's description, just as he followed Jefferson's indication for two doors in the west wall [27].

When Trumbull went to Philadelphia in May 1790, where he undoubtedly visited the Assembly Room, he must have been chagrinned indeed to find the architectural details of his painting were incorrect. But the painting was probably too far advanced with portraits collected in the six months since his arrival back in the United States to make changes. Benjamin West had always cautioned that it was better to start afresh than to paint over a composition, and Trumbull had followed this advice when he found he had

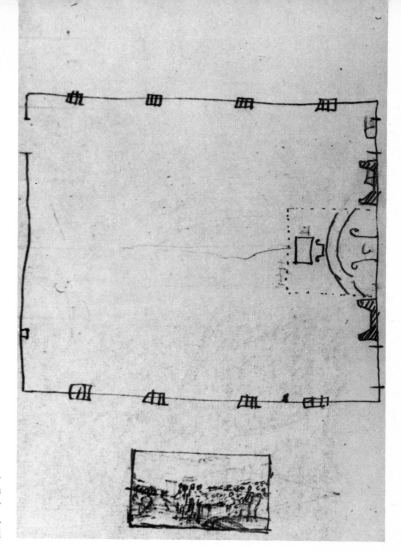

27. *The Declaration of Independence.*
Plan of the Assembly Room
(Independence Hall) and an early
sketch for the composition, *c.* 1786.
John Trumbull

made an error in the colors of the Spanish uniform in his *Sortie Made by the Garrison of Gibraltar* (1787); he finished that painting, anyway, and then painted a second version with the correct colors. Perhaps he intended to do the same with *The Declaration*: finish it, incorrect as it was, and then paint a second version with the architecture corrected.

But as it happened, Trumbull abandoned painting in 1793 for seven years, and a second *Declaration* did not immediately materialize. Then, when he returned to his profession in 1800 he apparently decided world affairs were not promising for the success of his pro-

ject and he turned to religious and literary subjects and unhappily, of course, to portrait painting. It was not until 1817, when he won the commission for the Capitol paintings, that he went back to the Revolutionary pictures. By that time, unfortunately, the Assembly Room had been renovated (1815) and he seems not to have made a sketch of it on visits to Philadelphia between 1790–93. He knew he could not remember the room accurately enough to depict it authentically after more than twenty years so he had no alternative, so he thought, but to repeat the design of the room as it appears in the first version. He did not realize he could have obtained valuable clues, at

28. *Congress Voting Independence,* 1796–1817(?). Edward Savage

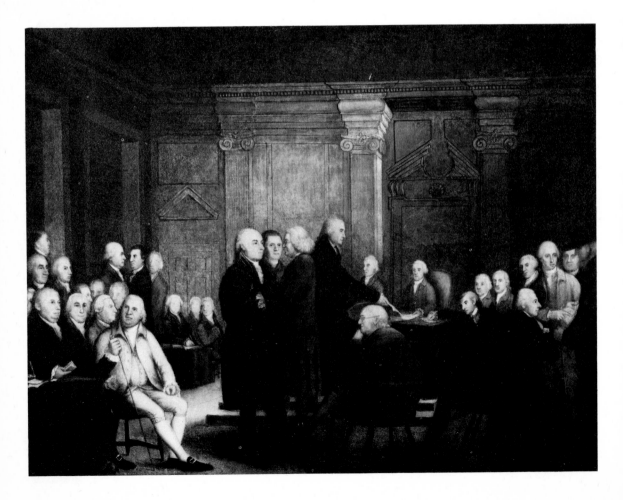

least to the Ionic style of the room, and the pedimented doors, from a painting by Edward Savage, *Congress Voting Independence* [28].

Savage lived in Philadelphia from 1795 to 1801, one block from the State House, and thus easily had first-hand knowledge of the Assembly Room. He painted his *Independence* over a span of years between 1796 and 1817, the year he died, and brought to near completion an engraving from it. His son wrote John Trumbull on 11 April 1818, having heard that the artist intended to publish an engraving after his painting on this subject. 'Sir, – I take the liberty to write you concerning the print of Congress '76 which my Farther (late Edward Savag) had nearly compleated. the same subject I understand you are about Publishing, as the one will hurt the other I do propose seling the Plate and Paper to you on liberal conditions . . . the Plate is now in a situation that it may be finish'd in a few weeks.'[52]

Trumbull of course wanted to emphasize his independent and prior claim to authenticity, and replied that since his work had been almost completed thirty years earlier, he now had no use for Savage's composition.[53] The engraving of *Congress Voting Independence* was never finished, so Trumbull could not have seen the print from it; it is unlikely that he ever saw the original painting.

Following the completion of the large *Declaration of Independence* in the summer of 1818, Trumbull exhibited the picture in New York and then took it on tour in Boston, Philadelphia and Baltimore before delivering it to the government in Washington. There is no record of criticism leveled against the painting on the grounds of the room's architectural inaccuracy, but it has been supposed there was, and that a drawing attributed to Joseph Sansom [29], a Philadelphia merchant, antiquarian, sometime artist and connoisseur of architecture was made in 1819, from memory, when the *Declaration* was exhibited in Philadelphia, to demonstrate the architectural errors in it.[54] Modern archaeological evidence, on the basis of which Independence Hall was restored during the 1960s, confirmed that Sansom's sketch shows the west wall substantially as it was origin-

p sq' 4 15 high to the cornij, 4 d' cornice

29. *The West Wall of the Assembly Room, c.* 1819. (Independence Hall), Joseph Sansom

ally, with one door at the center, pedimented, with alternating wide and narrow plaster panels, and with a coved ceiling. Why the drawing was made is still conjectural, however. Trumbull could have met Sansom, who it turned out remembered the room well, and perhaps requested that he make the drawing for him, with the thought that he might once again paint *The Declaration of Independence* with the setting correct. This he did in fact do.

In the early 1830s Trumbull began a third set of his historical paintings, intending to make all eight at half life-size for a projected but unrealized Trumbull Gallery in Hartford, Connecticut. He completed only five – *Bunker's Hill, Quebec, Trenton, Princeton,* and *The Declaration of Independence*. In this third version of *The Declaration* [30] the background conforms exactly with the Sansom sketch.

However the drawing of the west wall came to Trumbull's attention, or when, there can be no doubt that it did, and that he followed it for the Hartford picture: in 1896 when Benjamin Silliman III, grandson of Trumbull's nephew-in-law and estate executor, Benjamin Silliman, sold his inherited collection of Trum-

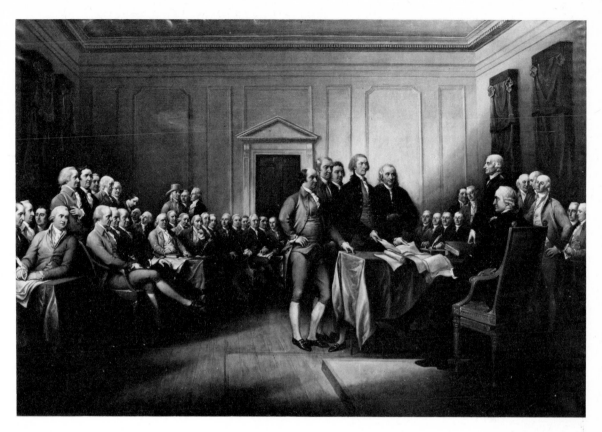

30. *The Declaration of Independence,*
1832. John Trumbull

bull works, papers, letters, and memorabilia at auction, the Sansom
drawing was listed as lot number 138 in the catalogue.[55]

In Trumbull's *Description of the Four Paintings*, his entry for
The Declaration of Independence includes the comment that 'the
room is copied from that in which Congress held their sessions at
the time, such as it was before the spirit of innovation laid unhal-
lowed hands upon it, and violated its venerable walls by modern
improvement, as it is called . . . In fact nothing has been neglected
by the artist, that was in his power, to render this a faithful memorial
of the great event.'[56] We must note the artist's careful phrasing,
'the room *is copied from* . . .' 'Copied from' is not the same as 'a copy
of'; it is somewhat like 'inspired by'. Trumbull had known the room

as represented in his small version was incorrect ever since 1790. The Sansom sketch must have come into his hands after he painted the Capitol picture, again too late to change it. But he felt strongly that his claim to posthumous fame rested largely on public belief in the authenticity of his image. And thus we must conclude that Trumbull's catalogue comment on the Assembly Room was deliberately misleading without being in fact untruthful. He did, of course, include an escape clause, 'nothing has been neglected . . . that was in his power.' If we are not archaeologists or social historians, the few inaccuracies of dress and furniture[57] can be overlooked perhaps as having arisen because it was beyond the artist's power to recreate, in the years between 1790–93, their exact details in every respect as they were in 1776. And since the conception of historical accuracy had not yet reached the level of scientific precision that it has now attained, Trumbull may be forgiven his overstatement. His transcendent purpose, after all, was commemorative.

From the first, Trumbull took his stand at the east wall. The problem of representing the scene from the west entrance, which would seem natural, was that Congress should face the dais, at the east, giving the viewer the backs of their heads. This was the view taken by Edward Savage [28]. The Congressmen are thus made to face the viewer at the expense of plausibility, turned away from the dais, and the members of the reporting committee are posed this way and that, with Franklin seen seated, in profile, as if they had nothing to do with Jefferson, handing the Declaration to John Hancock. By taking his view from the east, Trumbull eliminated this problem; while a few heads are turned away, the impression prevails that Congress unitedly faces the central group, intent on what is occurring.

In both early sketches [25, 27], Trumbull gives an oblique view of the room. Generally speaking, asymmetry seems more casual and naturalistic and this is probably why the artist eventually shifted his composition to a frontal design. The dignity and solemnity of the occasion, he came to feel, was better expressed through iconic

frontality, and he was willing to sacrifice dramatic spatial recession with its sense of immediacy in favor of a more stable space box which intensifies the spirit of gravity and ceremony. The sketches also show the perspective structure Trumbull made in which he constructed his picture space.

Although the original *The Declaration of Independence* was not completed with all its portraits in place until about 1820,[58] by the summer of 1787 the composition was settled and the canvas prepared for the portraits to be added, according to the method Trumbull describes in connection with the fourth of the American historical paintings, *The Surrender of Lord Cornwallis at Yorktown*. 'I drew it over and over again, and at last, having resolved upon the arrangement, I prepared the small picture to receive the portraits.'[59] One surviving study for the *Declaration* shows how he used his architectural setting to diagram the arrangement of some of the heads

31. *The Declaration of Independence*, *c.* 1791. John Trumbull. Sketch for placing the figures in relation to the architecture.

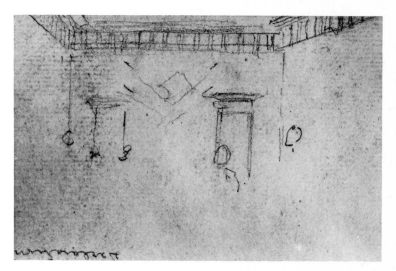

and figures [31]. Samuel Chase's head is placed so that it is bisected exactly by the vertical line representing the southwest corner of the room; Arthur Middleton's head is on the left door post of the south door, while George Clymer's is on the right one. Benjamin Franklin stands against the north door, and Charles Thomson is in place just

to the right of the northwest corner of the room. Radiographs show how Trumbull 'prepared the picture to receive portraits' [32]. Having determined with sketches the composition and basic relationships, he painted in the background, leaving pockets for faces and figures. One sees, for example, how Jefferson's head and shoulders are painted on the ground, and how Trumbull then painted the area immediately around him, stroking and restroking to make the head fit the pocket, and consequently building up multiple layers of paint. William Williams and Oliver Wolcott fit into a pocket also, but Trumbull did not build up the space around them. The 'light' behind them coming into the room – from one wonders where – was painted after the figures were in place. Trumbull left ground space for Benjamin Franklin's figure, but not his head; this was painted after the door

32. Radiograph of
The Declaration of Independence,
1787–1820. John Trumbull

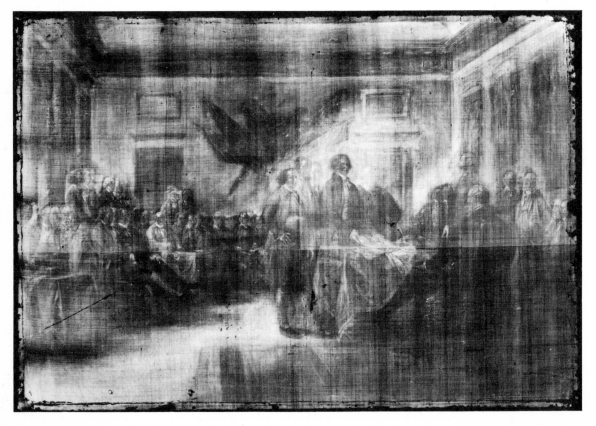

behind him, we know from evidence of an ultra-violet photograph of the back of the canvas where only the oil stains of shapes painted directly on the ground are visible.

Having consulted with Adams and Jefferson, Trumbull determined to portray all available Signers including those not present on 4 July, and such non-Signers as John Dickinson, a Quaker who had opposed the Declaration as premature, correctly reckoning it would bring on a full-scale war which he, unlike almost all the others, was unwilling to see. For this reason the title is not *The Signing of the Declaration of Independence*, but simply, *The Declaration of Independence*, underlining the painting's timeless, ideational and symbolic character.

There is very little precedent for a painting such as *The Declaration of Independence*. Religious subjects, battle and death scenes are inherently pathetic and moving. But how was one to take a large group of ordinary looking men – short, tall, fat, thin, young, middling, and elderly – dressed not in the glamorous costumes of European courts or the crimson robes of English lords but in simple, everyday American garb; placed in a room undistinguished by any architectural elegance, seated not on crimson and gold but plain Windsor chairs; leaning not on marble and ormolu tables, but desks covered with dull green baize; shown in the act of watching not the dramatic collapse of a national leader but the members of a committee presenting a report to the president of their body. How was one to dramatize these elements and create a painting that would speak to a nation's people as long as that nation survived? Trumbull chose not to dramatize. He depicts, instead, a strange and wonderful moment when tension and conflict – the stuff of drama – have been resolved: in a moment of intense silence and solemnity, an idea has triumphed.

Faced with the innumerable, difficult decisions that arise in the course of composing a scene with many figures, Trumbull, like all artists, would have looked at works by other painters, seeking helpful clues. Surely he considered possibilities offered by Copley's

Chatham, and he probably re-studied Hogarth's Conversation Pieces for their groupings. It is even likely that he looked for hints in Johann Zoffany's group portraits such as *The Academicians of the Royal Academy* [33]. A popular motif of the period was the presentation scene such as *The Piety and Generosity of Roman Women* [34], by Nicolas-Guy Brenet; Trumbull may have adapted some such painting for his principal group presenting the Declaration of Independence to John Hancock. There was, furthermore, the painting by Gerard ter Borch, *The Swearing of the Oath of Ratification of the Treaty of Münster*, which Trumbull could have known through an engraving or perhaps could have seen in a private collection in Amsterdam in 1781. One interesting and unexpected possibility is

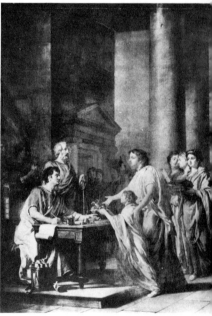

the influence of Raphael's *Disputà* [35], which Trumbull undoubtedly knew from engravings, since he never went to Italy. Raphael was widely held as the greatest of all masters of composition, and it is not unlikely that Trumbull would have consulted Raphael's works for assistance. The semi-circular arrangement of the congressmen in *The Declaration* who sit and stand under the wing-like image of the banners and trophies of the west wall – battle trophies taken in

victories against the British – even suggests the inspiration from the *Disputà* of the Holy Spirit hovering over the Host at the center of the Vatican fresco. Flags and banners conveniently filled in spaces in secular paintings that had been occupied by sacred or mystical motifs in religious ones – the flag behind General Wolfe in Benjamin West's painting is placed where one might expect to see a cross in a Deposition. The symbolic nature of banners gives them an emotional content that lent itself to secular subjects and replaced the earlier pious reverence. In the case of Trumbull's painting, especially, it is not stretching the imagination too far to suppose that

33 (*far left*). *The Academicians of the Royal Academy*, 1772. Johann Zoffany

34 (*left*). *The Piety and Generosity of Roman Women*, 1785. Nicholas-Guy Brenet

35 (*right*). *The Disputà*, 1509. Raphael

Trumbull saw in those trophies of victory at St Johns and Chambly the spirit of Providence present and guiding the Continental Congress; he had often heard his father speak confidently of American victories as evidence of Providence smiling on the American cause.

The 'heroes' of *The Declaration of Independence* are Jefferson, Adams, and Franklin, given the greatest prominence. Jefferson, tall, wearing a bright red vest, stands at the center of the reporting

committee, the document in his outstretched hands as he lays it on the table before the president. His pose, partly hidden by the table, is derived from the *ad locutio* pose which since Augustus Caesar has served as a proper image for statesmen and military heroes. John Adams, placed at the exact center of the painting, stands in a pose almost equally honored, associated with Van Dyck's *Charles I* which Trumbull had seen at Versailles the year before he painted Adams, 'the most perfect and loveliest of Van Dyck's portraits that has come to my view,' he noted in his journal for 18 August 1786.[60] Franklin is turned almost full face towards the viewer, reminiscent of William Penn in West's *Penn's Treaty with the Indians*; his head is set strongly in relief against the northwest door. Roger Sherman and Robert R. Livingston are secondary figures in this representation of an astounding moment in world history. The rest of the congressmen – forty-eight in the paintings at Yale and the Wadsworth Atheneum, forty-seven in the Rotunda version, with Thomas Nelson, Jr, missing – are clustered in groups of varying size, sitting, standing, a few with heads turned to add interest and variety while the prevailing atmosphere of quiet gravity and attention appropriate to the event is maintained. Without flourish, without heroic gesture, with no clenched fists, oaths, or mobs; with the associations of power and elegance transformed into sobriety and determination, Trumbull's painting is not grand, but achieves grandeur. There is not another like it in the world. The very immobility of the figures and the airlessness of the room suggest the frozen instant in which had been born the new state, to be led not by the caprice or ambitions of a monarch, but by the sweet dictates of republican Reason. The painting, like the Declaration that inspired it, American to the core, may be said to be an ultimate statement of European Enlightenment.

Jefferson, Adams and Trumbull had agreed that authenticity must be a prime concern in *The Declaration of Independence*; no idealized representation of a Founding Father should be introduced 'lest it being known that some were to be found in the painting, a

doubt of the truth of others should be excited in the minds of posterity.'[61] Accordingly, when Trumbull returned to the United States in 1789 he set about collecting portraits for this and the other history paintings already composed or contemplated. He travelled up and down the eastern seaboard, sometimes with his canvas at hand onto which he painted his sitters directly, sometimes making miniature oils and pencil sketches to serve as models from which he would work later. It is one of these small pencil portraits that reveals a curious case of mistaken identity in the Key to *The Declaration of Independence* – several mistaken identities, in fact, that have obtained until recently when the present writer in the course of studying Trumbull's drawings discovered the errors.[62]

On 3 September 1791 Trumbull was in Providence, Rhode Island, where he drew the portrait of Rufus Hopkins to stand in for his dead father – whom it was said he strongly resembled – Stephen Hopkins, Governor of Rhode Island, and a Signer. On the back of the pencil drawing the artist noted, 'Gove. () Hopkins/ Congress 1776 July 4/ Profile eye/ Brown complexion/ Gray Hair/ Providence 3 Sept 1791/ from his son Rufus Hopkins, Esq.,' the kind of notation made as a memory aid for painting the portrait into the picture [36]. Governor Hopkins is identified on the Key made at the time the painting was engraved by Asher B. Durand (see pull-out at end of book) between 1820 and 1823 as number 23, but a glance at the painting reveals there is no resemblance between number 23, the only man wearing a hat, and this drawing [37].

36. *Stephen Hopkins*, 1791 (Detail). John Trumbull

37. *The Declaration of Independence*, 1787–1820. (Detail; no. 23 in Durand Key.) John Trumbull

Scanning the faces of those represented, however, one quickly
notices that the drawing is most certainly of the man in position
number 8 [38], identified in the Key as George Clinton. Comparing
Trumbull's own portrait of Clinton [39] or other portraits of the
Governor of New York with number 8, it can again be seen there is
no resemblance. It appears Clinton must be removed from that

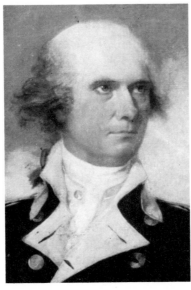

38 (*far left*).
The Declaration of Independence,
1787–1820. (Detail; no. 8
in Durand Key.) John Trumbull

39. *George Clinton*, 1791 (Detail).
John Trumbull

40. Sketch for *The Declaration of
Independence, c. 1817.* John Trumbull

chair, to be replaced by Hopkins. But then, where is Clinton to be placed, for it is easily seen he is surely not the man with the hat? Unfortunately we cannot make a simple swap.

There is happily a clue. In an earlier discussion of *The Declaration of Independence*[63] the present writer suggested that the man with the hat was a Quaker who, in observance of his beliefs, whether customarily or not when attending congress, kept his head covered on this solemn occasion. This hypothesis has been confirmed by a study for the painting that has now come to light on which Trumbull noted 'door top upper/ part nearly as high/ above the quaker hat/ as th / ? /' [40]. This study appears to be relatively late, after most of the heads and figures from William Paca, number 9, and on around the room had been painted, but before the table, studied in this sketch, and probably before Benjamin Harrison, number 5. That this section was largely a later addition, can be seen on an ultra-violet photograph of the back of the canvas, where only the oil stain of shapes painted directly on the ground are visible. The entire group from one to five, together with the table is absent from this photograph. This does not mean, however, that those in the group at the left were all painted at one time. From the radiograph [32] it appears that two, or possibly three figures were in place, and then shifted to make room for two more. Two of the earlier figures can be identified with a fair amount of plausibility. A pencil sketch of Josiah Bartlett in the New Hampshire Historical Society must have been made between 1789 and 1793, during Trumbull's stay in America, since Bartlett died in 1795; a pencil sketch of George Wythe now unlocated, but listed and described in the Silliman sale catalogue, was dated on the back, 'Geo. Wythe, 25th April '91.' These sketches would presumably have been used to paint in Bartlett and Wythe soon after they were made. If there is a third figure to be discerned in the radiograph, this would be Thomas Lynch, of whom Trumbull made a posthumous pencil sketch taken from a portrait by another artist. William Whipple was probably painted at about the same time as Benjamin Harrison,

which was not until 1817. This must have been when the table in front of Harrison was added. The radiograph reveals that a figure, probably Bartlett, was seated near the left-hand margin, perhaps with his legs crossed at the shins. Part of his head, his right shoulder with coat lapels, white neck-piece and vest with buttons are fairly clear. The table was painted over his legs which now show in the radiograph as if they are under the table, seen through the cloth.

The question is, Who *is* the man with the hat? Significantly, Trumbull specifically names Samuel Chase and William Paca in his notation above the study for the table, but he does not identify the man wearing the Quaker hat; his note merely refers to the 'quaker hat'. There are four candidates for the hat. Probably because of Trumbull's painting, Stephen Hopkins has been supposed to have been a Quaker. But although Hopkins was for a time a member of the Society of Friends, he was read out, it is known, on 25 March 1773, the Smithfield (Rhode Island) Monthly Meeting having censured him for his refusal to sell a Negro slave. As his biographer William E. Foster observes, the relationship with the pacifist Friends was altogether something of a strain for him as one of the leading militants among the colonial leaders. Charles Jenkins, considering Hopkins in connection with the Continental Congress, remarks that it is questionable 'whether he wore his hat in assemblies of this kind.'[64] Moreover, Hopkins was not married in a Quaker Meeting, nor was he buried as a Quaker.

Another candidate is Joseph Hewes, number 26 in the Key. Hewes was born into a Quaker family, and Charles Jenkins points out that he never relinquished his membership, or was disowned, and that his death was recorded in the records of his Chesterfield (New Jersey) Monthly Meeting. But a portrait taken from life [41] can be compared with Trumbull's representation of Hewes in *The Declaration* [42]. Hewes wrote John Iredell on 26 March 1776, 'I am getting my picture drawn in miniature.'[65] This is presumed to be the source for the only known portrait of Hewes, obviously Trum-

41. Joseph Hewes (Detail).
Engraving by J. B. Longacre
after a miniature
by Charles Willson Peale

42 (*far right*).
The Declaration of Independence,
1787–1820. (Detail; no. 26
in Durand Key.) John Trumbull

bull's model for this congressman, who died in 1779. The resembl-
ance is certain and Hewes may be left in position number 26.

Charles Humphreys was a Quaker all his life, buried in the Old
Haverford Meeting House cemetery. He voted against the Declara-
tion of Independence out of his conscientious objection to the
measure he knew meant war. Since Jefferson, Adams and Trumbull
had agreed 'that portraits ought . . . to be admitted of those who were
opposed to, and of course did not sign . . .'[66] his opposition would
not rule him out. There is, however, an important objection.
Humphreys died in 1786 leaving no descendant that could stand in
for a portrait, and no portrait taken from life, as far as we know. In
his discussions with Jefferson and Adams, Trumbull relates, it was
decided 'Wherever it was possible the artist should obtain his
portrait from the living person; that where anyone was dead, he
should be careful to copy the finest portrait that could be obtained;
but that in the case of death, where no portrait could be obtained . . .
he should by no means admit any ideal representation . . . absolute
authenticity should be attempted, as far as it could be attained.'[67]

It was within the spirit if not the letter of their discussion that
Trumbull could introduce the portraits of Benjamin Harrison and

William Whipple, both deceased, done from 'memory and description', as the artist wrote Jefferson, and it was not stretching the understanding too far to portray Stephen Hopkins, also deceased, from a life drawing of a son who closely resembled him. We have already considered the difference between twentieth-century standards of scientific history as compared with those of the eighteenth century. But if Trumbull had portrayed Humphreys from memory and description he should have mentioned him along with Harrison and Whipple in the letter to Jefferson. Since he did not, and since there was no reason to include him so compelling that Trumbull might have felt justified to override the limitations respecting authenticity, it may be presumed that he was omitted, and there is no reason further to consider that congressman from Pennsylvania as the possible wearer of the hat.

John Dickinson, a fellow Representative from Pennsylvania, number 45 in the Key, also lived and died a Quaker, was buried in the graveyard of the Friends Meeting House in Wilmington, Delaware. He had played a leading role in the Congress in formulating policy, supporting resolutions for redressing grievances and petitions to the king that recited injuries suffered by the American colonists. Nevertheless, he was convinced the Declaration of Independence was too radical a measure at that time and would make war inevitable; he still hoped for reconciliation, and risked his public career by refusing to sign the Declaration of Independence. When Robert E. Pine wrote Dickinson asking him to sit for a portrait in *his* painting of the scene, Dickinson declined. '. . . I cannot be guilty of so false an ambition,' he wrote Pine in 1785 'as to seek for any share in the fame of that council.'[68] Since Dickinson refused to sit for Pine we may take it that a man of such consistency also refused Trumbull, and we must wonder what model the artist could have used to portray him. Charles Willson Peale painted him twice [43]; neither of the portraits resembles number 45 [44], and although it cannot be said those portraits bear a strong resemblance to number 23, the hat-wearer, there is in fact not one face

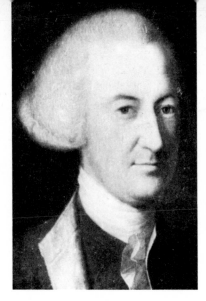

43. *John Dickinson*, 1782–3 (Detail).
Charles Willson Peale

44 (*center*). *The Declaration of Independence*, 1787–1820. (Detail; no. 45 [central figure] in Durand Key.)
John Trumbull

45 (*far right*). *John Dickenson* (Detail).
Engraving by B. I. Prevost after Pierre Eugène du Simitière

among all those portraits that does look more like Dickinson as he is represented in Peale's painting. A vague resemblance may be observed between the Dickinson profile as seen in the engraving after Pierre Eugène du Simitière [45] and the profile of number 45, but the likeness is of so slight and generalized a character as to be unpersuasive in view of the evidence of the Peale portraits. Du Simitière's Dickinson does not resemble Peale's at all.

There remain two possibilities for Trumbull's model. One is a crude engraving from Nathaniel Ames's *Astronomical Diary or Almanack* [46], the other is an engraving by James Smither [47]. In both, Dickinson's head is turned at an angle similar to that of figure 23, and both give us a striking resemblance to the man with the hat. One of them may have been the only source available to the

46. *Portrait of John Dickinson* (Detail).
From Nathaniel Ames,
Astronomical Diary or Almanack, 1772

47 (*far right*). *John Dickinson* (Detail).
James Smither (after Peale?)

artist who was apparently eager to represent Dickinson in the painting despite his refusal to sit. He singles out by name among the non-signing dissenters who Jefferson and Adams agreed should be included '. . . particularly John Dickinson . . . the most eloquent and powerful opponent of the measure, not indeed of its principle, but of the fitness of the act at that time, which he considered premature.'[69]

Why the Key is not correct is perplexing. Most likely the errors existed in the first Key (unlocated) which was evidently a hand-drawn one. In a letter of 19 February 1819 to the Virginia delegation in Congress Trumbull wrote that *The Declaration* hung in the 'Hall of Representatives' for 'more than a week in February 1817 accompanied with a Key and list of names.'[70] The errors were then repeated on the first printed Key, the so-called Durand Key given to purchasers of the engraving of *The Declaration of Independence* which Asher B. Durand completed in 1823. Trumbull was unsure of the identity of the Quaker it appears, since, as we have seen, he did not identify him by name on the study [40]. There seems to have been a tradition that Quaker hats were in evidence in Congress, worn by several Congressmen [48], and he may have become

48. *Première Assemblée Du Congrès* (Detail).
Engraving by Jean François Godefroy after Jean Jacques François le Barbier

confused about which man he had depicted with the hat, for he added heads at various times over the years. By 1817 when he exhibited the painting in the House of Representatives to stimulate interest in his proposal to execute his American series for the government, there were six survivors of those depicted: Charles Carroll, eighty years old; Thomas Willing, eighty-six; William Ellery, ninety; Adams, eighty-two; Jefferson, seventy-four; and Charles Thomson, eighty-eight. They were inactive, and of the younger men in Congress who saw the painting, few if any could have clearly remembered the faces of the Founding Fathers. No one, so far as we know, recognized the errors. And during the past century and a half the small Hopkins drawing lay unnoticed, first in the Silliman collection, then acquired by Charles A. Munn at the Silliman sale in 1896, who gave it with other Trumbull drawings to his niece, Mrs I. Sheldon Tilney, who in turn gave it and some of the others to Fordham University in 1943. The drawing was never exhibited or studied in all those years. The disparity between the pencil portrait, authenticated by the artist's own notation on the back, and the face keyed as number 23 and identified as Hopkins remained hidden, and the errors of identification continued. But errors there are: we can see, for example, that George Clinton is not number 8. But if not there, then where is he? Clinton, in fact, never signed the Declaration of Independence. It is possible he is not represented in the painting, despite Trumbull's inclusion of his name on the Key. But if he is, then the most likely possibility on the basis of resemblance – deep-set eyes and aquiline nose [44] – is position number 45, keyed as Dickinson. With this Pennsylvanian moved into position number 23, then, the hat may be bestowed on the non-signing, uncompromising Quaker, John Dickinson, thus ending this game of musical chairs with Trumbull's national anthem hopefully back in 'key'.

With *Bunker's Hill*, *Quebec* and *The Declaration of Independence* before us, John Trumbull's contribution to nineteenth-century naturalism in painting can be appreciated in a comparison with the

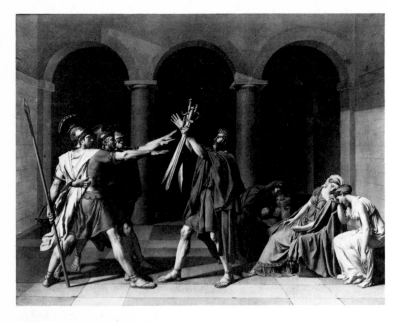

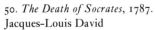

49. *The Oath of the Horatii*, 1785.
Jacques-Louis David

50. *The Death of Socrates*, 1787.
Jacques-Louis David

three great history paintings of Jacques-Louis David painted in the
same decade: *The Oath of the Horatii, The Death of Socrates*, and
The Lictors Bringing Brutus the Bodies of His Sons [49, 50, 51].
David's paintings represent scenes enacted by heroes who had

51. *The Lictors Bringing Brutus the Bodies of His Sons*, 1789. Jacques-Louis David

become in a sense canonized in western culture. The theme of self-sacrifice in the cause of patriotism or truth is stated, like a religious oration, so that the image assumes the character of ritual re-enactment. *Bunker's Hill, Quebec* and *The Declaration* on the other hand, while they also take up the theme of self-sacrifice – the Founding Fathers knew the risk they were taking when they voted for independence, and did not blink the consequences of defeat – are concerned with the here-and-now event instead of time-authenticated legend. The acts depicted by David had long before entered into mythopoeic consciousness; although referring to events in historical time, the significance of each is that of an eternally re-enacted event in mythopoeic time. *The Death of Socrates* in 1787 functioned on the twin levels of historicity and mythography, anchored in space and time but serving the realm of myth. *The Declaration* at the time it was painted was anchored in contemporary time and specific place, and only later, in the course of a developing national imagination could it begin to function as both real and symbolic; only in the distance of time could it become, as Trumbull

envisioned it, an icon of American culture. Every step forward is made at some cost, recuperated by history's changing system of values. Trumbull's move toward naturalism was made at the expense, in his own time, of iconic grandeur; in our time his paintings have more than retrieved their loss, with accrued interest.

An historical view of the relationship in art between objects represented and their meaning suggests that here, too, Trumbull moved decisively toward the nineteenth century. Whereas David's figures (objects represented) as a consequence of their mythopoeic role, are symbols of what-it-is-to-be-brave, Trumbull's figures are concrete examples of bravery. In *The Declaration* the men are meant to represent themselves, heroic in their naturalistically individualistic skins; in *The Oath of the Horatii*, the figures are intended to represent idealized heroes fashioned according to the rules of decorum in their stylistically individualized skins. A contemporary viewer could only see the former in the frame of nature, while he saw the latter in the frame of art, i.e., culture.

Despite its rhetoric, however, David's *Oath of the Horatii* is revolutionary in composition.[71] David breaks away from traditional methods of unifying a design such as pyramidal construction, or gathering forms along a diagonal or ellipse, or by strong lightbursts or chiaroscuro. In the *Horatii*, pictorial elements are separated, and their separation is emphasized by the three frontal arches. Pictorial unity is achieved through psychological interrelationships created by the oath-taking and it is not immediately noticed that the psychologically induced effect of unity is formally supported and controlled by means of the perspective structure that converges in the *foreground*, on the fist of the father holding the swords. David points the way to nineteenth-century painting by his radical composition; Trumbull's advance was in his creation of the *mise-en-scène*.

Thomas Sully once commented, with acute judgment, that he did not think Trumbull, whom he considered an excellent painter, was duly appreciated in London. 'His merit is neither generally

understood, nor valued. His last performance in the Exhibitions [of the Royal Academy] was far superior to any other work placed there; but the English taste is in favor of strong effects, & brilliant coloring; whilst the highest excellences of painting, which are design, and composition, are undervalued, unless accompanied by those *imposing* values. I think France would be a more favorable theatre for a display of Mr Trumbull's powers . . .' Sully's observation takes on heightened interest in the light of Jacques-Louis David's estimation that West, Copley, Trumbull and Washington Allston were the best painters in London. And it seems likely, in view of a memorandum on a sheet of pencil sketches for *Mirabeau and Deux Brézé* 'to borrow engravings of Trumbull and

52. *The County Election*, 1851. George Caleb Bingham

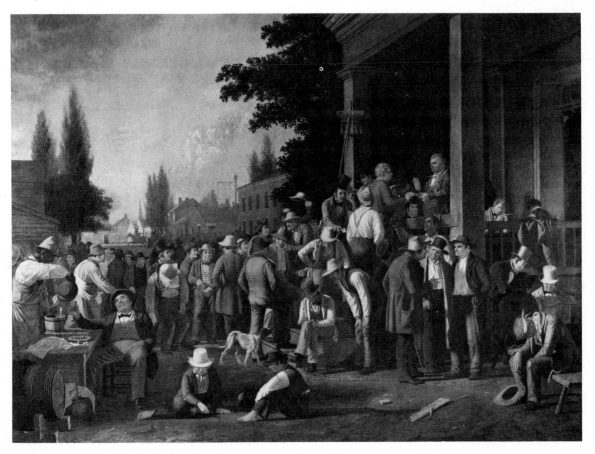

West',[72] that Delacroix studied Trumbull's engravings in preparation for his *Boissy d'Anglas at the Convention* and *Liberty Leading the People*.

Early on, American realism focused on the faces of Americans, usually the proud, important ones, and often on their personal property. In the nineteenth century American artists turned with more conscious purpose to landscape painting to document the features of the land, portraying its mountains, rivers, and broad expanses, and to genre, to portray everyday life among the people. Trumbull's recording of the Revolutionary War and its actors thus gives him a unique position in American art: in character of a history painter, he belongs to the end of a long European tradition, but he must also be placed at the beginning of a sturdy tradition in America: art as documentation. In this light we may see that George Caleb Bingham's mid-nineteenth-century *County Election* [52] has its roots in John Trumbull's *The Declaration of Independence*.

4. The United States Capitol Rotunda

John Trumbull's reasonable expectations of success and happiness arising from his welcome as an artist in the United States in 1789 and his hope of marriage to Harriet Wadsworth were smashed in 1793 by Harriet's death,[73] the Terror in France, and deteriorating Anglo–American relations. Plunged into gloom by his personal bereavement, and disillusioned with the French Revolution that had turned to violence, he apparently lost for a time his former driving ambition to memorialize the American Revolution. New subscriptions for *Bunker's Hill* and *Quebec* fell off, perhaps partly because others, like him, lost their taste for revolution.[74] When John Jay was chosen early in 1794 by President George Washington to try to negotiate a treaty with Great Britain in the hope of resolving long-standing conflicts so that the United States could remain neutral vis-à-vis the struggle between France and England, Trumbull accepted Jay's invitation to accompany him to London as secretary to his mission. With the conclusion of the Jay Treaty, Trumbull stayed on in England as a commissioner on article seven of the Treaty, and until 1800 abandoned not only the American history series but painting altogether.

But in 1800 he married Sarah Hope Harvey, an English woman of obscure background and, with the end of the commission's work in sight, he returned to painting as a profession. Except for four years in New York from 1804 to 1808, Trumbull lived for the next fifteen years in England, trapped on the eve of his departure in 1812 by the outbreak of war between England and the United States, and forced to remain until peace was restored. His attempt to establish

himself there as a painter was unsuccessful. The English were obviously not interested in pictures celebrating American victories against themselves; his reputation as an American patriot brought him few English sitters for portraits; and so he turned to religious and literary scenes – one of the first artists to find subject matter in the poetry of England's new literary star, Sir Walter Scott. He returned to America in 1815.

In the wake of peace, the United States was experiencing a great surge of expansionist and nationalist spirit. One of the first projects authorized by an enthusiastic Congress was the restoring and finishing of the Capitol, burnt by the British in 1814, and the time was ripe for Trumbull's proposal to memorialize the nation's birth by ornamenting the new building with scenes from the Revolution.

Trumbull's artistic credentials for carrying out this splendid plan were the best in the country. He alone among American artists had the portraits from life on which the documentary value of the paintings depended. No other artist in America had the training, experience and skill to compose so many figures as the scenes required. He had, in fact, no competition, and his problem was principally to have Congress persuaded to commission the work. Although he had broken with Jefferson in 1793 after a dinner party at Monticello where a bitter argument over religion had developed, he sought and gained his old friend's support for the commission.

'I have been very long and intimately acquainted with Col. Trumbull,' Jefferson wrote Senator James Barbour of Virginia on Trumbull's behalf, 'and can therefore bear witness of my own knoledge [*sic*] to his high degree of worth as a man. For his merit as a painter I can quote higher authorities, and assure you that on the continent of Europe, when I was there, he was considered as superior to West . . . I pretended not to be a connoisseur in the art myself, but comparing him with others of that day I thought him superior to any historical painter of the time except David; it is in the historical line only that I am acquainted with his painting . . . The subjects on which Col. Trumbull has employed his pencil are honorable to us, and it would be extremely desirable that they

should be retained in this country as monuments of the taste as well as of the great revolutionary scenes of our country.'[75]

Trumbull also wrote his old friend John Adams, whose answer is a model of American bluntness, goodwill, and aesthetic suspiciousness.

'Your kind letter [of 26 December] has given me more pleasure than it would be prudent or decent for me to express. Your design has my cordial approbation and best wishes. But you will please to remember that the Burin and the Pencil, the Chisel and the Trowell, have in all ages and Countries of which we have any information, been enlisted on the side of Despotism and Superstition. I should have said of Superstition and Despotism, for Superstition is the first and Universal Cause of Despotism. Characters and Counsels and Action merely Social, merely civil, merely political, merely moral are always neglected and forgotten. Architecture, Sculpture, Painting, and Poetry have conspir'd against the Rights of Mankind; and the Protestant Religion is now unpopular and Odious because it is not friendly to the Fine Arts. I am not, however, a Disciple of Rousseau. Your country ought to acknowledge itself more indebted to you than to any other Artist who ever existed; and I therefore heartily wish you success. But I must beg Pardon of my Country, when I say that I See no disposition to celebrate or remember, or even Curiosity to enquire into the Characters, Actions, or Events of the Revolution. I am therefore more inclined to despair, than to hope for your success in Congress though I wish it with all my heart.'[76]

With the help of these Founding Fathers, and others of Trumbull's influential friends, the proposal, with his fee of $32,000 was accepted and the artist set immediately to work on *The Declaration of Independence*. He wrote Jefferson and Adams to thank them for their assistance. 'You will be pleased to see that this nation has departed from the general system and has given a preference to two great Political and moral Events. I hope the Example thus set will be hereafter followed, in employing the Arts in the Service of Religion, Morality and Freedom.'[77]

On the crest of his new success Trumbull determined to under-
take once again the production of an engraving. The subject was
The Declaration of Independence. Initially he planned to have the
engraving executed by James Heath, in London, because American
engravers were principally experienced in banknote engraving and
none, he thought, had the skill to engrave a work of aesthetic quality.
His broadside announcing the publication and promising the work
would be done by the most eminent artist in Europe drew criticism
however on the grounds that 'everything about this great national
picture should be American.'[78] In 1819 the work of Asher B.
Durand caught his attention, and it is to Trumbull's great credit
that he recognized the talent of the then unknown twenty-two-
year-old artist and entrusted to him the work of engraving the
painting that meant more to him than any painting he ever made.

53. *The Declaration of Independence*,
1823. Engraving by Asher B. Durand
after John Trumbull

But despite the fact that Durand's engraving turned out to be one of the masterpieces of American graphic art [53], its commercial success was far less than Trumbull anticipated. It is hard to understand why, at twenty dollars each, Trumbull did not manage to sell thousands of prints. In his lifetime it is doubtful that he sold more than five or six hundred; when he died there were hundreds of prints left to the heirs of his estate.

The government's *The Declaration of Independence*, however, was a huge success for the artist. The painting was officially exposed to public view on 5 October 1819 at the American Academy of the Fine Arts, of which Trumbull was then President.[79] The gallery thronged with visitors eager to see the first of the great works destined for the national Capitol, and the *New York Commercial Advertiser* reported the event the following day. '*The Declaration of Independence* . . . is now exhibited in the room of the Academy of Fine Arts . . . It would not comport with the limits of a newspaper to comment upon the splendid picture with critical minuteness . . . In design and execution, in keeping, coloring, and perspective, in its minuter touches, and in its general effects, it is every way worthy of the event it records . . .' The *New York Daily Advertiser* devoted its editorial comment on 8 October to the picture. 'To suppose that any native American can go back in recollection or his imagination to the period when this great event took place, and not feel a deep interest in the actual view of the personnages by whom it was achieved would be a species of reproach which we are not willing to cast on any fellow citizen. The nation is deeply indebted to the artist . . .' By the end of the week 1,886 persons had paid the twenty-five cents admission charge, and when the regular exhibition closed on 7 November, 6,375 visitors not counting city officials and special guests had seen the painting. It was left hanging one more day as a benefit exhibition for the recently established Deaf and Dumb Institution to which Trumbull turned over the proceeds of $332 paid by 1,328 persons.

Approval of the painting was not completely unanimous, how-
ever; an anonymous writer signing himself 'Detector' objected
strenuously and at long length in a letter published in the *National
Advocate* to the 'errors' he found in Trumbull's work. 'It is not my
intention to examine the merits of this production as a specimen of
the arts,' he began, 'it may, perhaps, be a *very pretty picture*, but
it is certainly no representation of the Declaration of Independence
. . . To make the "national painting" . . . subservient to a display of
the likeness of any American, however distinguished, who was not
both a member of Congress and present in that body when Inde-
pendence was declared, is . . . ridiculous . . .'[80]

Colonel Trumbull was angry. With cold scorn, he thanked
'Detector' for the opportunity of laying before the public, through
the *New York Daily Advertiser*, an account of the origin and
development of the *Declaration*, which took place under Thomas
Jefferson's roof and with his advice. The question 'Detector' so
shrewdly discovered, the artist went on, was one that he and
Jefferson had carefully pondered: who were the men actually
present on the Fourth of July: 'The journals of Congress are silent;
it would be dangerous to trust the memory of anyone – and the only
prudent resource was to take as a general guide the signatures to the
original instrument, although it was well known to Mr Jefferson and
Mr Trumbull then as it is now to the sagacious "Detector" that
there were on that instrument the names of several gentlemen who
were not actually present on the Fourth of July; and also, that
several gentlemen were then present who never subscribed.'[81]

Trumbull was correct. The only names on the first printed copy
of the Declaration of Independence, attached to the original manu-
script Journals of Congress as a part of the official record of the
proceeding on 4 July 1776 are those of John Hancock who signed
the document as President of Congress, and Charles Thomson who
attested the signature as secretary. On 19 July, Congress adopted a
resolution that the Declaration passed on 4 July be engrossed on
parchment and signed by every member of Congress. The 'official'

signing took place on 2 August, although not all members were present, so that some signed later. In the meantime, some who were members of Congress on 4 July were no longer so, and others, newly appointed, signed even though they could not have been present on that day, as for example, Benjamin Rush, George Clymer, James Smith, George Taylor and George Ross, all of Pennsylvania, who were not appointed until 20 July. The signatures, Trumbull and Jefferson knew, did not constitute certain evidence as to who was present on 4 July; 'thus the record was taken as a general guide,' Trumbull explained, 'and with regard to all the most important characters represented in the painting, there was, and (begging my sagacious friend's pardon) there is no doubt.'[82]

With the successful New York exhibition over, Trumbull sailed on 23 November for Boston where he arrived three days later to prepare his exhibition at Faneuil Hall. On 30 November *The Declaration of Independence* was ready for Boston's judgment, and once again his success was all he could have hoped. Every day the Hall was crowded with visitors, and John Adams, now eighty-three years old, came from Quincy to see and applaud Trumbull's picture.[83] At the end of the first week Trumbull wrote his wife to tell her the good news. 'My dearest friend,' he began, using the eighteenth-century form of address customary between loving couples as well as close friends, 'The whole of the last week has been remarkably fine here, cold but clear & favorable to walking – of course favorable to me – the receipts of the Six days are something more than Six hundred dollars . . .' The exhibition continued to draw crowds, he wrote her a few days later. 'I have received $973 – this week will produce something but not much as we have snow on the ground & the walking is sloppy . . .' Contrary to his expectations, and despite bad weather, the last week attracted 2,500 visitors, bringing the Boston exhibition to a close on 19 December with total receipts equal to those of the New York show.[84]

In Philadelphia a few weeks later 5,000 people came to see the picture during the ten days it was on view at the Old State House,

and in Baltimore almost 3,000 more viewers brought the total audience for the four exhibitions to about 21,000. Net receipts came to $4,215. The tour had been an unprecedented professional and financial triumph.[85]

On 16 February 1819 *The Declaration of Independence* was turned over to the government, ready for 'inspection', as Trumbull informed Secretary of State John Quincy Adams, in a committee room opposite the entrance to the Senate Chamber, since the Rotunda was still under construction. In March he began the second of the government pictures, *The Surrender of Lord Cornwallis at Yorktown*, which he finished in June of the following year. Hoping to duplicate the success of the previous exhibition, he arranged to take *Yorktown* on tour, but the new picture did not attract the crowds that had turned out to see *The Declaration of Independence*. The subject lacked the deep emotional appeal of the Declaration of Independence, the anniversary of which was marked by celebrations throughout the nation. Visitors totalled slightly under 7,000. The artist delivered the painting to the government in November 1820, and began work a few weeks later on the third picture, *The Surrender of General Burgoyne at Saratoga* which he finished in December 1821. In view of the unsuccessful tour of *Yorktown*, Trumbull exhibited *Saratoga* in New York only, from 9 January to 8 March 1822, and then brought the painting directly to Washington. The final painting of the commission, *The Resignation of Washington*, was executed between Spring 1822 and Spring 1824. Probably because his wife died just as he was finishing it, and he was anxious to get away from New York, he took *The Resignation* on tour after showing it in the city, but attendance in Boston, Providence, Hartford, New Haven, Albany and Philadelphia was poor. He delivered the picture at the end of the year.

The Rotunda was not ready to receive Trumbull's paintings until November 1826, although it had been under construction since July 1817 when Benjamin Latrobe finished the fourth side of the north wing of the Capitol which thus formed the first section of the

great circular room. The architect was honored in having his walls destined to support Trumbull's paintings of the Revolution, he wrote the artist, but his design for the wall created serious difficulties for hanging them. The wall was to be articulated by great arch-headed niches set twenty-four feet apart, with stone-work margins of three feet on each side, allowing only eighteen feet for each picture together with its frame. The lower edge of the frames would be three feet above the floor. The paintings were to be placed in recesses worked in the walls, but since these would also be curved, there would be a versed sine of about one foot. Latrobe suggested stretching the paintings on concave frames, reducing their specified size, and narrowing the width of the proposed frames [54].[86]

54. Wall design for the United States Capitol Rotunda and for framing Trumbull's paintings, 1817. Benjamin Latrobe

Trumbull maintained that under the terms of his contract, he could not alter the size of the paintings, and returned a counter suggestion. Latrobe's stone margins, Trumbull pointed out, only

ran up to the springing of the arches. The paintings would not encroach on the niches if they were hung from bronze rings on the wall above the molding that departed from the springing point [55].

55. Wall design for the United States Capitol Rotunda, 1817. John Trumbull

Trumbull was anxious about curious fingers touching the paintings, were they to hang so low. As for stretching them on concave frames, this, he explained, would simply not work.[87]

The architect's principal objection to Trumbull's plan was that the paintings would have to hang forward in order to be seen at such a height and in such lighting conditions; this would create a problem for the viewer, who would have to stand forty to fifty feet away in order to overcome the effect of foreshortening. Reverting to his own plan, Latrobe conceded the frames could be raised so that the lower edge would be five and one-half feet from the floor, and a railing could be placed around the Rotunda three feet from the wall, to safeguard the paintings. He could allow nineteen feet between the arches, and agreed the paintings could be stretched flat, on straight frames which would be shaped shallow at the center, and widen towards the extremities. Meanwhile, Latrobe's continuous disagreements with the Commissioner of the Capitol, Colonel Samuel Lane, were sharpening to the point of crisis. He had constantly to fight his way along and finally on 20 November 1817 he sent in his resignation as the only alternative, he wrote President Monroe, to keeping his self-respect.[88] Trumbull's long-

time friend Charles Bulfinch was immediately appointed to the vacated position.

It was not long before Bulfinch, too, found himself in trouble with the Rotunda. Everyone had opinions, he wrote Trumbull, and he was being pulled in all directions; he needed the advice of someone familiar with architectural and aesthetic problems, and would welcome the artist's suggestions. He was thinking, he said, of redesigning the center section on the plan of New York's City Hall, incorporating a similar grand staircase; Trumbull's paintings, in that case, would hang in a picture gallery devised in the space.[89]

Trumbull was horror-stricken. To have his Hall of the Revolution taken from him now after it seemed so perfectly assured would be an unbearable disappointment. 'I feel the deepest regret at the idea of abandoning the circular room,' he wrote the new architect. '. . . I should be deeply mortified, if, after having devoted my life to recording the great events of the Revolution, my paintings . . . should be placed in disadvantageous light. In truth, my dear friend, it would paralyze my exertions . . .' He had worked out several plans he hoped the architect might consider, which would save the Rotunda, and he was sending the drawings to Washington to make clear his ideas [56, 57]. 'I want not a column nor a capital; plain solid walls, embellished only by four splendid door-casings of white marble and elegant workmanship; a fascia of white marble running around the room, with an ornament somewhat like [the guilloche] which surmounts the basement story of the outside; and a frieze crowning the top of the wall, where, either now or at some future time, basso-relievos may be introduced; these are all the decorations which I propose, except the paintings.'[90]

Although some of the drawings have disappeared, the principal differences between the artist's plan and Latrobe's, which he was anxious for Bulfinch to scrap even while advocating the retention of the Rotunda, are evident in those that have survived, and in Trumbull's letter. Trumbull brings the grand staircase into the Rotunda and he smooths out the walls: the latter change reflects

the difference in sensibility between painter and architect. While Latrobe, in the Soane tradition, liked to scoop out walls in order to emphasize them, Trumbull preferred an uninterrupted surface so that the wall would 'disappear', functioning only to support the

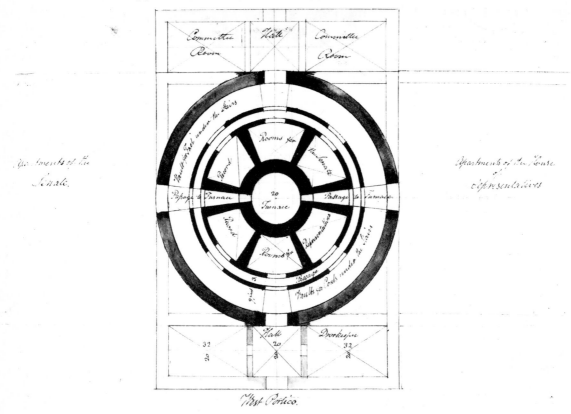

paintings. 'I shall rejoice, if, either upon my plan or some other, you can succeed to preserve the great central circular room,' he wrote Bulfinch, 'indeed I must entreat you to preserve it if possible . . . [with] the loss of that . . . unrivalled situation and light for my pictures I shall loose half my zeal. Forgive the earnestness with which I write, for I consider my future fame involved in this question . . .'[91]

Trumbull's letter persuaded Bulfinch to retain the Rotunda, but now Congress was getting impatient with aesthetics. The Senators

56 (*left*). Plan for the basement story of the United States Capitol Rotunda, 1818. John Trumbull

57. Proposed section through the United States Capitol Rotunda, 1818. John Trumbull

and Representatives were murmuring rather loudly that already too much of the building was devoted to 'shout and parade'. Bulfinch had better be sure that enough space was given over to committee rooms and offices, they warned him, or they would refuse to vote the appropriation for the Rotunda and insist on that space being cut up for more practical purposes. Spurred by this threat, Bulfinch devised the plan of sinking the center section one story and projecting it from the wings, gaining space for thirty committee rooms, a court

room, offices, a library, and a reading room. 'I am almost afraid to ask your opinion of this basement,' he confessed to Trumbull, not without betraying a certain pride in his solution, 'it was a resource of necessity . . . if you can recollect any precedent that will warrant it I will thank you even if I lose by it all claim to originality; I know several respectable gentlemen's seats in England which have one story more on one front than on the other, but do not recollect any, where this story is not continued for the whole length.' Cannily understanding the limits of an untrained visual imagination, Bulfinch had a model made in wood of his new design for the President and Congress to see. This was probably the winning stroke, for, after viewing it, Congress voted $100,000 for going on with the building immediately.[92]

It is clear from his letters that Trumbull's overriding concern in preserving the Rotunda design – however much he appreciated it for its own sake – was motivated by self-interest. We may thus thank the artist's egocentric ambition for saving the Rotunda, and giving the United States its most magnificent public room. In following Trumbull's request for simplicity so that the walls would serve principally as support for his paintings, Bulfinch went beyond even the artist's hopes. Replacing Latrobe's grand niches with colossal pilasters, Bulfinch framed each painting space within an architectural unit, thus making the architecture an active partner, rather than a passive support, in a coherent aesthetic and iconographic scheme [58]. The walls are scooped out not in fact, but illusionistically by the three-dimensionality of the paintings, and the spectator looks 'through' the frames into the historical past which is thus integrated with his living present.

The Rotunda, the panels on which the paintings were stretched, the frames, ornamented and gilded, all was finally ready for Trumbull's arrival in Washington on Friday 18 November 1826, to install the great canvases. On Saturday he dined with the President, the following day *en famille* with the Bulfinches. From Monday through Saturday he worked with the masons and carpenters getting the

58. United States Capitol Rotunda. Charles Bulfinch. View from the top of the dome

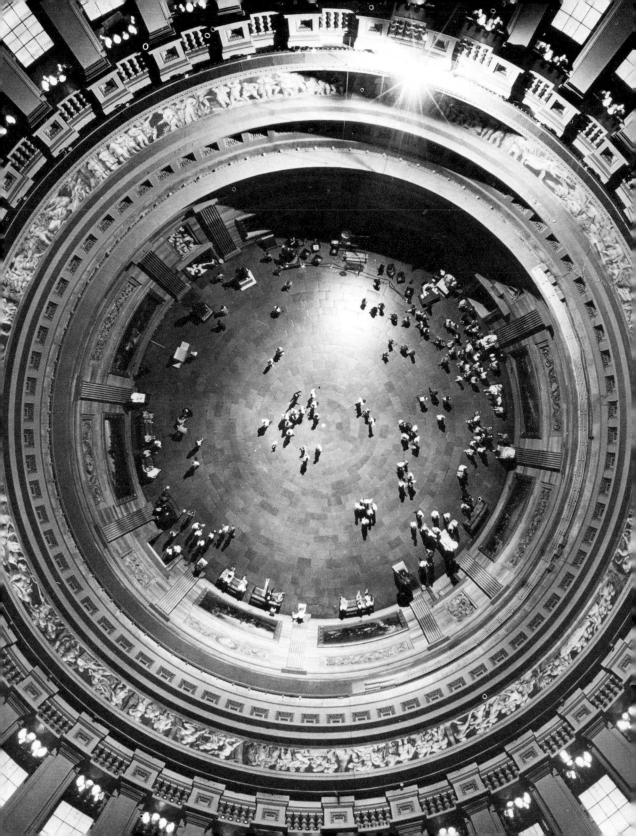

paintings strained and put into place, and on Monday 28 November, President John Quincy Adams joined him under the great dome of the Rotunda to view the four paintings in place.

It takes no connoisseur's eye to see that the Rotunda paintings fall considerably below the artistic achievement of the small *Declaration* (Color plate) and the Yale *Yorktown* [5]. They deserve, however, far more admiration than they have received. While the 'touch and coloring', as William Dunlap wrote, lack the vivacity of the small paintings, it should be remembered that history painting is committed to more than aesthetics. There is a realm of the imagination in which the sense of the good and the beautiful is transformed into a single experience of the true – the experience which generations of viewers have felt, looking at these paintings. Moreover, whatever aesthetic inadequacy is found in the Rotunda group must be measured against the success of its unified iconography and expression. A *summa* of Trumbull's ideals, the four paintings embody the lofty aspirations realized in the American Revolution, with which his ideals were identified. The Founding Fathers, Trumbull wrote, were not 'an Assembly of men raving of visionary theories – & quarreling for the next occupation of the Tribune from which to spout their undigested rhapsodies, & to display their frothy eloquence.' In *The Declaration* he has shown them in quiet, earthy colors consonant with their sober dignity; he saw them like Roman Senators, 'calmly, wisely, sternly adopting an Act at the hazard of their lives & Fortunes, which in less than half a Century has operated the political miracle of transforming young, feeble, disunited Colonies into a Nation happy, powerful & united.'[93] Trumbull could rant at the 'supranatural wisdom' of American leadership that was in his view guilty of error after error in politics and diplomacy: he never doubted America was the home of republican Virtue under a Providence that protected it beyond the intrigues and ineptness of its government and politicians.

In *Saratoga* [3], placed next to the *Declaration* and contrasting outdoors with indoors, civil sobriety with military pomp and eti-

quette, the artist exploited the colors of nature in autumn to provide a muted gold, sky-blue and white background for the bright red, white and blue in the military uniforms and the American flag flying over General Horatio Gates's marquee. General Gates at the center, with his chief-of-staff Colonel Morgan Lewis prominent to his left, receives General Burgoyne, attended by General William Philips; Burgoyne has dismounted, his horse held by a groom behind him, and offers his sword, which Gates magnanimously refuses with a gesture inviting his captive into the tent to partake of refreshments.

Paired with *Saratoga* in color and depth of field, *Yorktown* [4] represents the moment when General Charles O'Hara, acting for Lord Cornwallis who was 'ill', stands between the lines of mounted French and American officers at the head of the British surrender party. Originally keyed as Lord Cornwallis, the identification was removed because of strenuous objections to the historical inaccuracy; Cornwallis was known not to have tendered the surrender in person. The artist's attitude with regard to historical accuracy was more flexible than that of some of his public and peers; the facts of history, he thought, could be sacrificed to the meaning of history. According to William Dunlap, when a witness to Washington's first inauguration as President described the scene to Trumbull, 'Here stood Washington, in a suit of brown American broadcloth; there stood Chancellor Livingston, prepared to administer the oath . . . and here stood Mr Otis, supporting the Bible,' the artist commented, 'I would place a more important personage in that situation.' The historian Dunlap disapproved, 'Thus the truth of history is to be sacrificed to effect or flattery.'[94] But for Trumbull there was no question of 'effect' or 'flattery'; the representation of an event of such significance demanded the presence of significant persons for the meaning of the scene to be fully expressed. Trumbull gave in to protests, however, when *Yorktown* was exhibited, and Cornwallis and his aides became 'principal British officers'; the artist was apparently unable to discover the name of Cornwallis's substitute, O'Hara.

Yorktown, like *Saratoga*, is a bright-colored scene of military ceremony. Both paintings record American victories, 'Yet,' the artist notes, 'not an Eye or a Movement is . . . expressive of Exultation;' both surrenders portray 'men of the same race as those of the Fourth of July – men who can conquer but [are] too highminded to wound the feelings of a fallen enemy.'[95] For this reason, although in preparatory sketches 'Cornwallis' is shown hatless, humbled in defeat, in the finished painting, the principal British officer is permitted his hat, allowing him his dignity.

The Resignation [6], paired with *The Declaration*, again takes up the theme of lofty-minded dedication to republican principles. Its somber tonality in deliberate contrast with the bright colors of military pomp emphasizes the anti-militaristic meaning of Washington's resignation. 'Beloved by the military, venerated by the people, who was there to oppose the victorious chief, if he had chosen to retain that power . . . he had so long held with universal approbation,' Trumbull asks. 'The Caesars – the Cromwells, the Napoleons – yielded to the charm of earthly ambition, and betrayed their country . . . Washington alone aspired to loftier, imperishable glory – to that glory which virtue alone can give.'[96] The scene represents Washington at Annapolis where Congress was then sitting. In his right hand he holds the resignation that may well have been the American license to liberty. Pairing Washington in *The Resignation* with Jefferson in *The Declaration*, Trumbull underlines the meaning of Washington's action as a reaffirmation of the Declaration of Independence; at issue in both events was the commitment to republican government. It is altogether a fine conception and in completing the series makes of the four paintings a richly resonating hymn to the Republic, throughout which the themes of the Declaration of Independence – human liberty and dignity, and the necessity to struggle to achieve them – are elaborated and realized.

As a national image, *The Declaration of Independence* has gone deep into American consciousness. Planned in company with Jefferson and Adams, the painting expresses in visual form the convictions

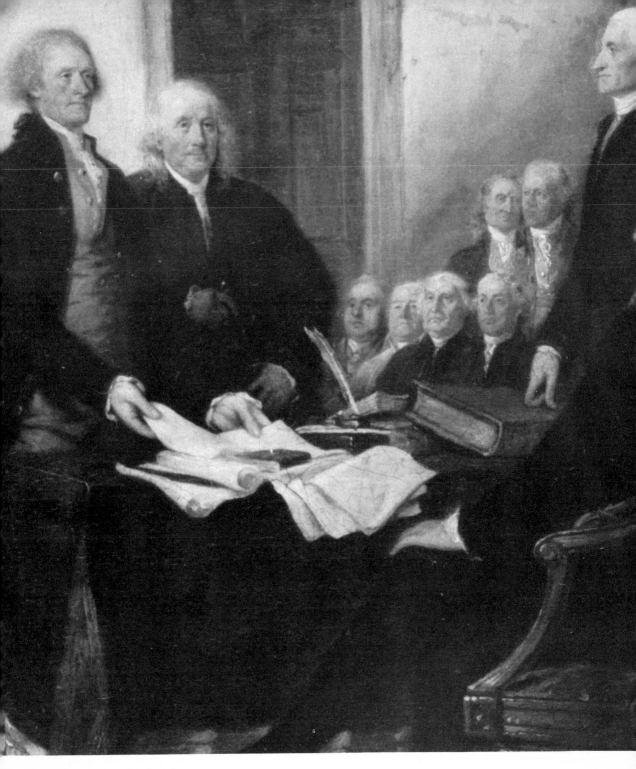

59. *The Declaration of Independence,*
1787–1820 (Detail). John Trumbull

and aspirations of those who framed the Declaration. In his own language the painter speaks equally with the Founding Fathers of moderation and resolve; he mirrors the profoundest belief of the eighteenth century in the power of representative government and republican principles to build and lead nations in dignity and freedom, nations in which dissent is honorable and prevailing policy is the consequence of open, reasonable discussion. The sober plainness of Trumbull's style echoes the clear, direct rhetoric of the document laid on the desk of John Hancock on 4 July 1776, and – if the present writer has correctly interpreted the artist's meaning – the painting's only flourish, the adornment of the west wall, re-affirms the Declaration's own inspirational conclusion in evoking the protection of Divine Providence.

'We therefore, the Representatives of the United States of America, in General Congress Assembled, appealing to the Supreme Judge of the world for the rectitude of our intentions, do, in the Name, and by authority of the good People of these Colonies, Solemnly Publish and Declare, That these United Colonies are, and of Right ought to be Free and Independent States . . . And for the support of this Declaration, with a firm reliance on the protection of Divine Providence, we mutually pledge to each other our Lives, our Fortunes, and our sacred Honor'.[97]

Notes

1. John Trumbull, *Autobiography, Reminiscences and Letters of John Trumbull, from 1756 to 1841*. New York, London and New Haven, 1841, pp. 262–3. Hereinafter, Trumbull, *Autobiography* (1841).

2. JT to James Madison, 26 December 1817, Yale University Library, Trumbull Papers.

3. JT to Francis B. Winthrop, 14 August 1810, Fordham University Library, Charles A. Munn Collection.

4. Henry Wadsworth Longfellow, *Tales of a Wayside Inn* (1861) 'The Landlord's Tale: Paul Revere's Ride': 'Listen, my children, and you shall hear/Of the midnight ride of Paul Revere.'

5. I. W. Stuart, *Life of Jonathan Trumbull, Sen.*, Boston, 1859.

6. Trumbull, *Autobiography* (1841), p. 48.

7. Stuart, *Jonathan Trumbull* (1859), p. 185.

8. Trumbull, *Autobiography* (1841), p. 15.

9. JT to Thomas Jefferson, 11 June 1789. Julian Boyd, *Papers of Thomas Jefferson*, XV: 176–9.

10. See Irma B. Jaffe, *John Trumbull: Patriot-Artist of the American Revolution*, New York Graphic Society, 1975, Chapter 4, for fuller discussion of JT's imprisonment.

11. JT to Jonathan Trumbull, Jr, 15 August 1784, Connecticut Historical Society, Trumbull Papers.

12. Trumbull, *Autobiography* (1841), p. 13.

13. JT to Jonathan Trumbull, Jr, 14 July 1786, Yale University Library, Trumbull Papers.

14. The *Self Portrait* of 1774, in private hands, was not made available for illustration here. See Theodore Sizer, *The Works of Colonel John Trumbull* (New Haven, 1967) fig. 63.

15. JT to Jonathan Trumbull, Jr, 18 July 1784, Yale University Library, Trumbull Papers. JT to David Trumbull, 17 June 1784, Connecticut Historical Society, Trumbull Papers.

16. Jonathan Trumbull, Jr, to JT, 10 December 1784, Yale University Library, Trumbull Papers. Jonathan Trumbull, Sr, to JT, 29 April 1785, Connecticut Historical Society, Trumbull Papers.

17. JT to Jonathan Trumbull, Sr, 27 May 1784, Connecticut Historical Society, Trumbull Papers.

18. Jean-Francois, Marquis de Chastellux, *Travels in North America*. 2 vols. Howard C. Rice (ed.) University of North Carolina Press, Chapel Hill, No. Carolina, 1963, I: 75; 259, *n* 44. JT to Jonathan Trumbull, Sr, 15 March 1785, Connecticut Historical Society, Trumbull Papers. JT to Andrew Elliot, 4 March 1785, Massachusetts Historical Society, Andrew Elliot Papers.

19. Gordon S. Wood (ed.), *The Rising Glory of America 1760–1820*, New York, 1971, p. 61.

20. JT to Jonathan Trumbull, Jr, 17 April 1784, Connecticut Historical Society, Trumbull Papers.

21. JT to Jonathan Trumbull, Jr, 25 September 1784, 18 January 1785, Yale University Library, Trumbull Papers.

22. William Whitley, *Artists and Their Friends in England, 1700–1799*, 2 vols., London, 1928, II: 43. JT to Jonathan Trumbull, Jr, 15 November 1784, Yale University Library, Trumbull Papers.

23. See Edwin H. Cady, *The Gentleman in America*, Syracuse (New York), 1949.

24. Jonathan Richardson, *Theory of Painting*, London, 1715, pp. 29–30.

25. John Galt, *The Life of Benjamin West*. A Facsimile Reproduction with an Introduction by Nathalia Wright. 2 vols. in 1. Gainesville, Florida: Scholars' Facsimiles and Reprints, 1960, II: 47–50.

26. Giuseppe Baretti, *A Guide Through the Royal Academy*, London [1781], p. 26.

27. JT to Gov. Jonathan Trumbull, Sr, 3 November 1784, Connecticut Historical Society, Trumbull Papers. JT to Jonathan Trumbull, Jr, 18 January 1785, Yale Trumbull Papers.

28. Whitley, *Artists and Their Friends* (1928), I: 358.

29. Jules D. Prown, *John Singleton Copley*, 2 vols. Cambridge, Mass., 1966, II: 338 *n* 6. Also see Robert Anthony Bromley, *A Philosophical and Critical History of the Fine Arts, Painting, Sculpture and Architecture*, 2 vols., London, 1793, I: 45–63.

30. Trumbull, *Autobiography* (1841) p. 11.

31. Prown, *Copley*, II: 308.

32. Emil Staiger, *Der Briefwechsel Zwischen Schiller und Goethe*, Frankfort am Main, 1961, pp. 455-6.

33. Sir Joshua Reynolds, *Discourses on Art*, London, 1797, discourse 3.

34. John Trumbull's charge-out record, Harvard College Library, 1772.

35. William Hogarth, *The Analysis of Beauty*, London, 1753, pp. 190-91 and pl. 24, fig. 1.

36. Baretti, *Guide*, gives a descriptive list of casts in the collection of the Royal Academy.

37. JT to John Trumbull Ray, 10 July 1811, Yale, Trumbull Papers.

38. Benjamin Silliman, 'Notebook', p. 17, Yale, Trumbull Papers.

39. *The Complete Essays and Other Writings of Ralph Waldo Emerson*, edited by Brooks Atkinson, New York: Modern Library, 1950 ('The American Scholar'), p. 61.

40. Albert Ten Eyck Gardner and Stuart P. Feld, *American Painting: A Catalogue of the Collection of the Metropolitan Museum of Art*, New York, 1965, pp. 29-30.

41. William Dunlap, *A History of the Rise and Progress of the Arts of Design in the United States*, 3 vols., Boston, 1918, II: 233-4.

42. JT to Harriet Wadsworth, 30 October 1791, Yale University Library, Trumbull Papers.

43. JT to Jonathan Trumbull, Jr, 13 September 1785, Yale University Library, Trumbull Papers.

44. See John R. Howe, Jr, 'Republican Thought and the Political Violence of the 1790s,' *National Unity on Trial*, E. James Ferguson (ed.), New York, 1970, pp. 75-92.

45. JT to Lafayette, 25 November 1799, New-York Historical Society, Trumbull Papers, letterbook 1796-1802.

46. Marie Kimball, *Thomas Jefferson, The Scene of Europe 1784-1789*, New York, 1950, p. 61.

47. *Catalogue of valuable oil paintings, many of them by the old Masters*, and all choice pictures, being the collection of the late President Jefferson, to be sold at auction, on Friday, July 19, at Mr Harding's gallery, School St (1833).

48. Trumbull, *Autobiography* (1841), p. 59.

49. JT to Harriet Wadsworth, 12 January 1790, Yale University Library, Trumbull Papers.

50. JT to Jonathan Trumbull, Jr, 27 December 1786, Yale University Library, Trumbull Papers.

51. Trumbull, *Autobiography* (1841), p. 96.

52. Cited by James M. Mulcahy, 'Congress Voting Independence, The Trumbull and Pine-Savage Paintings,' *The Pennsylvania Magazine of History and Biography*, LXXX, no. 1 (January 1956), p. 88.

53. ibid.

54. Lee H. Nelson, 'Restoration in Independence Hall: a continuum of historic preservation', *Antiques*, July 1966, pp. 64-8.

55. Stan V. Henkels, *Catalogue of the Very Important Collection of Studies and Sketches Made by Col. John Trumbull*. Philadelphia, 17 December 1896.

56. John Trumbull, *Description of the Four Paintings From Subjects of the Revolution*, New York, 1827.

57. Mulcahy, op. cit., pp. 81-2.

58. A full discussion of the dating of *The Declaration of Independence* is given in Irma B. Jaffe 'Trumbull's *The Declaration of Independence*; Keys and Dates', *American Art Journal*, Fall 1971, pp. 41-9.

59. Trumbull, *Autobiography* (1841), p. 148.

60. ibid., p. 112.

61. John Trumbull, *Description of the Four Paintings* (1827).

62. Jaffe, 'Fordham University's Trumbull Drawings', *American Art Journal*, Spring 1971, especially pp. 5-14.

63. ibid.

64. Charles F. Jenkins, 'Joseph Hewes, the Quaker Signer,' *Children of Light*, Howard H. Brinton (ed.), New York, 1938, p. 213.

65. ibid., p. 230.

66. Trumbull, *Description of the Four Pictures* (1827).

67. ibid.

68. Charles J. Stillé, *The Life and Times of John Dickinson*, Philadelphia, 1891, p. 318.

69. Trumbull, *Description of the Four Pictures* (1827).

70. New-York Historical Society, Trumbull Papers.

71. See Hugh Honour, *Neo-classicism*, Harmondsworth (England), 1968, p. 36.

72. Thomas Sully to Daniel Wadsworth, 17 June 1810, Connecticut State Library, Governor Joseph Trumbull Collection, Military and General Correspondence. David is quoted by Theodore Bolton in 'A Portrait of Benjamin West', *Art in America*, October 1920, p. 278. Delacroix' drawing cited by Frank A. Trapp, *The Attainment of Delacroix*, Baltimore and London, 1971, p. 109.

73. Harriet Wadsworth was sent to Bermuda in the autumn of 1792, suffering from tuberculosis. Her family hoped the milder climate would be beneficial but she died there on 10 April 1793.

74. *The Death of General Warren at the Battle of Bunker's Hill*, engraved by Johann Gotthard von Müller, and *The Death of General Montgomery in the Attack on Quebec*, engraved by Johan-Frederik Clemens, were published in February 1798.

75. Jefferson to James Barbour, 19 January 1817, New York Public Library, James Barbour Papers.

76. John Adams to J T, 1 January 1817, mounted in Trumbull's three volume interleaved *Autobiography* (1841), vol. I, Yale University Library.

77. J T to John Adams, 3 March 1817, Trumbull's interleaved *Autobiography* (1841), I, Yale University Library.

78. Letter to *New York Daily Advertiser*, 11 March 1818, signed 'Rittenhouse'.

79. J T was elected President of the American Academy on 18 January 1817; he was re-elected annually and remained in office until he resigned in 1836.

80. *National Advocate*, 20 October 1818, reprinted in *The Portfolio*, VII (1819): 84–6. 'Detector' was not alone in finding fault with the *Declaration*. Senator Charles Tait of Georgia wrote J T that he was prepared to find fault, having heard 'much criticism', but found himself applauding instead. 'It is a fine painting,' he wrote J T. 'I have no doubt [it] will be proved to be a work honorable to the artist and to Congress . . . an honorable immortality awaits you.' (25 February 1819, New-York Historical Society, Trumbull Papers.) The most damaging criticism aimed at *The Declaration* was that of John Randolph of Virginia in 1820. He dubbed it 'the Shin-piece' because he claimed he never saw so many legs in a painting. Randolph was a caustic-tongued phrase-maker, but his observation is inaccurate; one sees that J T recognized the problem and managed by placing tables strategically to conceal many legs. The clever sound of Randolph's phrase, however, has given it clinging power; it has been irresistible to art critics and historians and with their help has stuck to the painting without warrant. (See United States Government, *Register of Debates*, 8 January 1828, IV, pt. 1:930.)

81. *New York Daily Advertiser*, 22 October 1818, reprinted in *The Portfolio*, VII (1819): 86–7.

82. ibid.

83. Adams is said to have pointed to the door 'next to Hancock' with the exclamation, 'There! that is the door out of which Washington rushed when I first alluded to him as the man best qualified for Commander-in-Chief of the American Army.' (Quoted by William H. Downes, 'Boston Painters and Paintings', Part I, *Atlantic Monthly* (July-December 1888) p. 96). There *is* no door, of course, next to Hancock in the painting, although there *was*, in actual fact: Washington rushed out of the southeast door, not represented in J T's painting. Either the remark is an invention, or more likely Adams 'saw' what he expected to see.

84. J T to Sarah Trumbull, 6 December 1818; 14 December 1818, Yale University Library, Trumbull Papers.

85. The financial and attendance record of the exhibitions of *The Declaration* (and the other government paintings) is in an account book, New-York Historical Society, Trumbull Papers.

86. Benjamin Latrobe to J T, 22 January 1817, Yale University Library, Trumbull Papers; 11 July 1817, New-York Historical Society, Trumbull Papers (photostat of now missing original at Yale).

87. J T to Latrobe, 25 September 1817, New-York Historical Society, Trumbull Papers.

88. Latrobe to J T, 11 July 1817, 10 October 1817, Yale University Library, Trumbull Papers. Charles E. Fairman, *Art and Architecture of the Capitol of the United States of America*, Washington, 1927, pp. 40–41.

89. Bulfinch's plan is inferred from J T's reply to him, 25 January 1818; see Trumbull, *Autobiography* (1841), pp. 265–6.

90. J T to Bulfinch, 28 January 1818, Trumbull, *Autobiography* (1841), pp. 266–72.

91. ibid.

92. Bulfinch to J T, 17 April 1818, Library of Congress, Trumbull Papers.

93. J T's comments about the Signers is found in Miscellaneous Notes [*c.* 1826], New-York Historical Society, Trumbull Papers. The artist's political correspondence makes lively reading. 'Supranatural wisdom' was a favorite sneer at what he considered the bungling ineptitude of some American statesmen, especially during the years 1808–12, leading to the war with Britain.

94. William Dunlap, *A History of the Rise and Progress of the Arts of Design in the United States*, 3 vols. Boston, 1918, II: 57–8.

95. Trumbull, Miscellaneous Notes [*c.* 1826], New-York Historical Society, Trumbull Papers.

96. Trumbull, *Description of the Four Pictures* (1827).

97. There were fifty-six Signers to the Declaration of Independence. Forty-three are represented in the painting. Those omitted are Carter Braxton, Button Gwinnett, Lyman Hall, John Hart, Francis Lightfoot Lee, John Morton, John Penn, Caesar Rodney, George Ross, James Smith, Thomas Stone, George Taylor and Matthew Thornton. Those included but who did not sign are George Clinton, John Dickinson, Robert Livingston and Thomas Willing. Charles Thomson is represented in the painting as congressional secretary, not a Signer.

A Bibliographical Note

PRIMARY SOURCES

Papers: The largest collection of John Trumbull letters and other documents is held by the Manuscripts Division of Yale University Library. Among collections of Trumbull family papers, the largest are in the Connecticut State Library and the Connecticut Historical Society.

Catalogues: Trumbull himself wrote the copy for the catalogues of his exhibitions. In 1827 he published *Description of the Four Pictures, from Subjects of the Revolution, Painted by Order of the Government of the United States,* printed by William A. Mercein. This is the source for the 'Mercein' Keys. A one-man exhibition at the American Academy of the Fine Arts in 1831 was accompanied by the catalogue, *Catalogue of Paintings by Colonel Trumbull, Including Nine Subjects of the American Revolution.* At the opening of the Trumbull Gallery in New Haven in 1832, built by Yale to house Trumbull's paintings which he gave to the College in exchange for a life annuity of $1,000, Trumbull published a catalogue of the works comprising the bequest. This catalogue was expanded in subsequent editions (1835; 1841; 1852; 1860; 1864) to include more Trumbull works, but the text for those listed in the 1832 edition remained substantially unchanged.

PUBLISHED WORKS

Trumbull's *Autobiography, Reminiscences and Letters of John Trumbull from 1756 to 1841* (New York and London, and also New Haven, 1841) is a basic text. It omits much of importance in the artist's life, but its reliability as far as it goes is confirmed by Trumbull's letters and other documents such as account books. Almost all subsequent writings on Trumbull are drawn from information in the *Autobiography* and from William Dunlap's *A History of the Rise and Progress of the Arts of Design in the United States* (originally published in 1834, edited and republished by Frank W. Bayley and C. E. Goodspeed and Company, Boston, 1918) which contains a lengthy biographical sketch of the artist. Dunlap's unfriendly account has long been recognized as rancorously distorted but nevertheless his image of the fourth President of the American Academy of the Fine Arts as a snobbish, self-serving tyrant has been reflected in most references to Trumbull. Theodore Sizer's *The Works of Colonel John Trumbull* (New Haven, 1950; revised 1967) is principally an authenticated checklist of almost 1,000 works by Trumbull. The book has, inevitably, some errors, mostly in matters of dates, but remains a basic reference of great value. The 1950 edition includes a comprehensive bibliography. Sizer also edited Trumbull's *Autobiography,* which was published under the title of *The Autobiography of Colonel John Trumbull* (New Haven, 1953). The present writer's *John Trumbull: Patriot-Artist of the American Revolution* (New York Graphic Society, 1975) is the only full length study of the artist's life and works, and is based on original research and primary sources. This book does not repeat the Sizer bibliography but expands it to bring it up to date (1975).

List of Illustrations

All works by John Trumbull except where otherwise indicated.
Measurements in inches, height × width.

paper, $7\frac{1}{4} \times 9\frac{1}{4}$. Historical Society of Pennsylvania. (Photo: Historical Society of Pennsylvania).

28. Edward Savage: *Congress Voting Independence.* 1796–1817 (?). Historical Society of Pennsylvania. (Photo: Historical Society of Pennsylvania).

29. Joseph Sansom: *The West Wall of the Assembly Room* [Independence Hall]. *c.* 1819. Collection of George Vaux, Bryn Mawr, Pennsylvania.

30. *The Declaration of Independence.* 1832, New York. Oil on canvas, 72×108. Wadsworth Atheneum, Hartford, Connecticut. (Photo: Museum).

31. *The Declaration of Independence*: sketch for placing figures in relation to architecture. *c.* 1791 (?), New York (?). Pencil on white paper, $2\frac{1}{4} \times 4\frac{7}{8}$. Historical Society of Pennsylvania. (Infra-red photo: National Park Service).

32. *The Declaration of Independence*: Radiograph. (Photo: Philadelphia Museum of Art, Conservation Department).

33. Johann Zoffany: *The Academicians of the Royal Academy,* 1772. British Royal Collection. (Photo: A. C. Cooper, Ltd).

34. Nicolas-Guy Brenet: *The Piety and Generosity of Roman Women.* 1785. Château de Fontainebleau.

35. Raphael: *The Disputà.* 1509. The Vatican. (Photo: Vatican Museum).

36. *Stephen Hopkins*: detail, 1791, Providence, Rhode Island. Pencil on white paper, $5 \times 3\frac{1}{8}$. Fordham University. (Photo: Roy Drake).

37. *The Declaration of Independence*: detail, number 23.

38. *The Declaration of Independence*: detail, number 8.

39. *George Clinton*: detail, 1791, New York. Oil on canvas, $108 \times 71\frac{1}{2}$. New York City Hall. (Photo: Alfred H. Miller Co.).

40. *The Declaration of Independence*: sketch for table at left, etc. *c.* 1817, New York. Historical Society of Pennsylvania. (Photo: National Park Service).

41. J. B. Longacre: *Joseph Hewes* (engraved from miniature by Charles Willson Peale): detail. (Photo: New-York Historical Society).

42. *The Declaration of Independence*: detail, number 26.

43. Charles Willson Peale: *John Dickinson*: detail, 1782–3. Independence Hall, Philadelphia. (Photo: Independence National Park, Philadelphia).

44. *The Declaration of Independence*: detail, number 45.

45. Pierre Eugène du Simitière: *John Dickenson* [*sic*]. Engraved by B. I. Prevost. Emmet Collection, New York Public Library. (Photo: New York Public Library).

46. Anonymous: *Portrait of John Dickinson.* From Nathaniel Ames, *Astronomical Diary or Almanack.* 1772.

47. James Smither: Engraving of *John Dickinson* (after Charles Willson Peale?). (Photo: The Library Company of Philadelphia).

48. Jean Jacques François le Barbier: *Première Assemblée Du Congrès.* Engraved by Jean François Godefroy, 1783–4. Massachusetts Historical Society Print Collection. (Photo: National Park Service).

49. Jacques-Louis David: *The Oath of the Horatii.* 1785. Louvre. (Photo: Alinari).

50. Jacques-Louis David: *The Death of Socrates.* 1787. Metropolitan Museum of Art. (Photo: Alinari).

51. Jacques-Louis David: *The Lictors Bringing Brutus the Bodies of His Sons.* 1789. Louvre. (Photo: Service de documentation photographique, Réunion des Musées Nationaux).

52. George Caleb Bingham: *The County Election.* 1851. St Louis Art Museum, St Louis, Missouri. (Photo: Museum).

53. Asher B. Durand: *The Declaration of Independence.* Engraved after John Trumbull, 1823. New-York Historical Society. (Photo: New-York Historical Society).

54. Benjamin Latrobe: Wall design for the United States Capitol Rotunda, and design for framing Trumbull's paintings. 1817. New-York Historical Society. Xerox of original letter formerly at Yale, now missing.

55. Wall design for the United States Capitol Rotunda. 1817. New-York Historical Society. (Photo: New-York Historical Society).

56. Plan for the basement story of the United States Capitol Rotunda. 1818. New-York Historical Society. (Photo: New-York Historical Society).

57. Proposed section through the United States Capitol Rotunda. 1818. New-York Historical Society. (Photo: New-York Historical Society).

58. Charles Bulfinch: United States Capitol Rotunda, View from the top of the present dome. 1850s, Thomas U. Walter. (Photo: United States Capitol Historical Society).

59. *The Declaration of Independence*: detail.

Index